Collins

YOU CAN PAINT

People in Watercolour

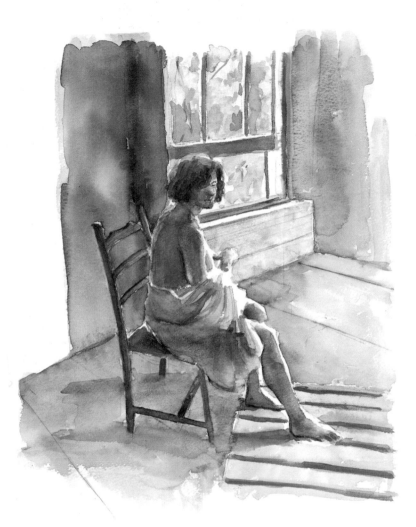

SHARON FINMARK specializes in life painting in watercolour, pastels and acrylics. She was Artist-in-Residence for BBC Radio 4's *Today* programme in 2001 and has sketched backstage at the National Theatre and with The Royal Shakespeare Company, sketching actors such as Robert Lindsay as Richard III, Ian Holm and Barbara Flynn in King Lear. Her sketch of Robert Lindsay was shortlisted for the prestigious Garrick Milne Prize in September 2000. She is a visiting lecturer in art at a range of institutions, and has written a number of books as well as being a regular contributor to *The Artist* magazine.

YOU CAN PAINT

People in Watercolour

A step-by-step guide for
ABSOLUTE BEGINNERS

Collins

SHARON FINMARK

The author would like to acknowledge the help of
Hannah, Sam, Moyra, Louise, Marcus, Tim, Jeanette,
Madeline and Felicity in the making of this book.

First published in 2002 by
Collins, an imprint of
HarperCollins*Publishers*
77-85 Fulham Palace Road
Hammersmith
London W6 8JB

Collins is a registered trademark of
HarperCollins Publishers Limited

The Collins website address is
www.collins.co.uk

03 05 07 06 04 02
2 4 6 8 7 5 3 1

A catalogue record of this book is available from the British Library

Editor: Isobel Smales
Designer: Penny Dawes
Photography: George Taylor

ISBN 0 00 711856 2

Colour reproduction by Colourscan, Singapore
Printed and bound by Bath Colourbooks

CONTENTS

INTRODUCTION

F igure work is one of the most exciting and rewarding of all painting subjects, and figures can add atmosphere to a painting and even hint at a story. Paintings of interiors and landscapes look very empty and lack ambience without the interest of people within them, and this book will enable you to add convincing figures to your paintings.

Most beginners find the idea of painting people a bit daunting, and mistakenly think that they need years of experience working from models and attending life classes to paint people successfully. In this book I will introduce you to the subject of painting people by starting with the most basic elements that make up a person: the colour of their skin, the proportions of their bodies and the shape of their heads, hands and feet. I will then lead

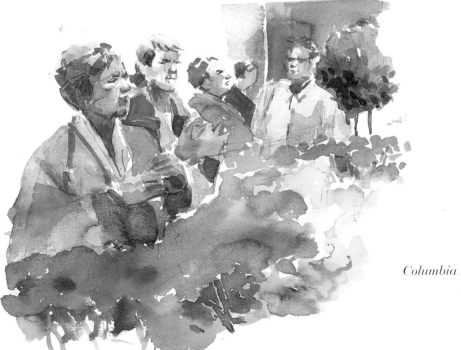

Columbia Market,
London

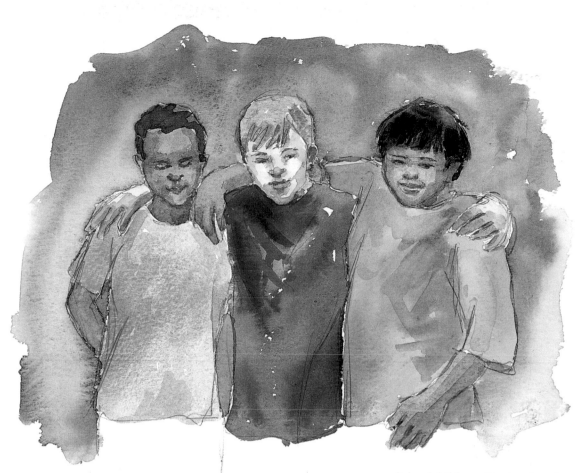

*Schoolchildren, illustrating the
natural way they liked to pose*

you on to painting figures in a variety of poses
and in different situations.

As people, we know so much about the
details of our bodies that we can make the
mistake of trying to include too much detail
when adding figures to our paintings. The
more objective we can be in our painting the
better, attempting more of an impression or
a simple statement. Just as when you are
painting a landscape you would not attempt
to include all the leaves on a tree, so you do
not need to include all the detail in people's
eyebrows or hair.

Your 'models' can be your own family and
friends, or may be people in photographs you
have taken or have found in magazines.
Taking photos is very helpful when painting a
moving subject, as the camera freezes the
motion for you to paint in your own time.

Watercolour is an excellent medium for
painting people as it gives swift, fluid results
without the need to include too much detail.
As with all painting, your confidence will
gradually build with your experience. If you
take time to practise the stages shown in this
book it will give you the confidence to have a
go at painting subjects of your own choice.
I am sure that before long you will enjoy
bringing your own paintings alive with
convincing figures.

HOW TO USE THIS BOOK

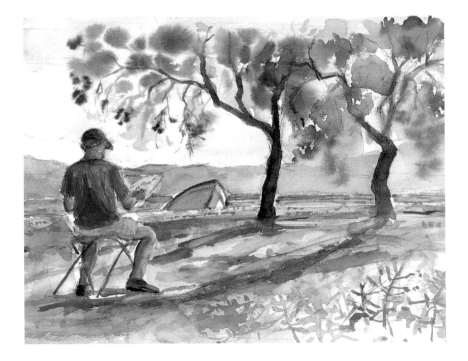

This is an instruction book for absolute beginners, aiming to help you produce realistic figures in your paintings. It describes the materials you will need, then gives you advice on handling your watercolours and demonstrates different ways of working with them. It is worth taking some time getting to know your paint and how it behaves before you embark on the exercises.

The book then describes the basic techniques you will need to master: how to get the proportions of your figures right, how to mix convincing skin colours, the way to paint realistic heads, hair, hands, arms and feet. After showing you how to combine these elements in paintings of single figures, it goes on to demonstrate how to paint people in groups, people moving about, and how to put people in convincing settings. The text is deliberately kept short and the idea is for you to practise the step-by-step examples until you have gained enough confidence to tackle subjects of your own choice.

When you come to try the more detailed demonstrations, don't be put off by the

Painting on the island of Crete

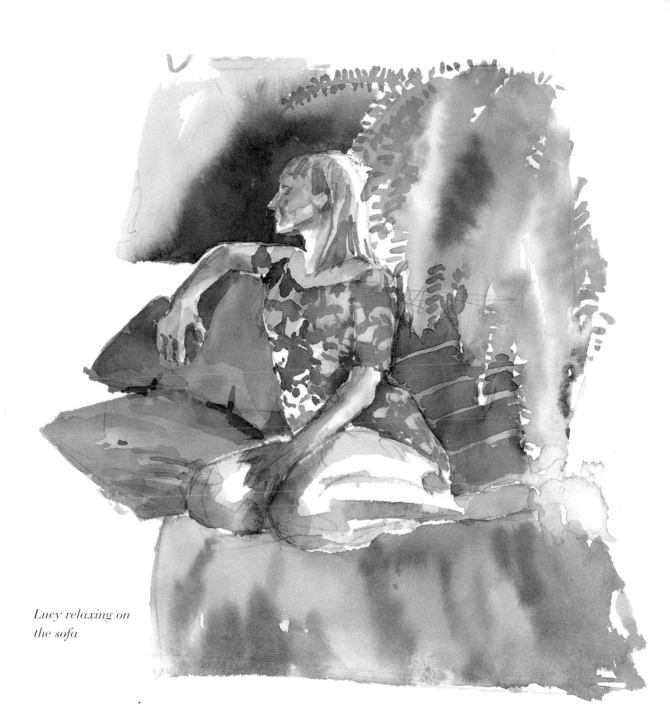

Lucy relaxing on the sofa

complexity of the finished picture, as it is merely the end result of a number of more simple stages. By following these stage by stage, you will see how they combine to develop your painting.

If you practise each subject until you have mastered it, by the time you have finished working through the book you will have developed the confidence to have a go at painting people in almost any situation.

BASIC MATERIALS

As a beginner, you will not need an expensive or extensive range of materials to start with. It is best to keep things simple. The basic materials are a pencil, paint, brushes and paper.

Colours These are available in tubes and pans: tubes are ideal for larger work. There are two qualities of watercolour paints, Students' and Artists', and I recommend Artists' quality. The essential colours are the primaries – blues, reds and yellows – which cannot be produced from mixtures of other colours. I use quite a variety of colours in this book, listed below and shown opposite, but you can be flexible in your range of colours and you may even have some already that you could substitute.

The colours I use are:
Rose Madder
Cadmium Red
Alizarin Crimson
Permanent Rose
Lemon Yellow
Cadmium Yellow
Naples Yellow
Cadmium Orange
Raw Sienna
Burnt Sienna
Vandyke Brown
Burnt Umber
Sepia
Black
Payne's Grey
Indigo
French Ultramarine
Cobalt Blue
Prussian Blue
Violet
Emerald Green
Viridian
Hooker's Green
Gold Green.

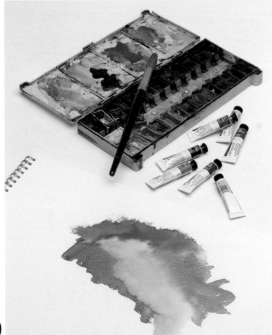

Pans and tubes of watercolour

Rose Madder

Raw Sienna

French Ultramarine

Cadmium Red

Burnt Sienna

Cobalt Blue

The colours used in this book

Alizarin Crimson

Vandyke Brown

Prussian Blue

Permanent Rose

Burnt Umber

Violet

Lemon Yellow

Sepia

Emerald Green

Cadmium Yellow

Black

Viridian

Naples Yellow

Payne's Grey

Hooker's Green

Cadmium Orange

Indigo

Gold Green

Brushes The brush must be a soft hair (mixed/synthetic) round; a size 10 and a size 6 are fine for both detail and broader work. The higher the number, the larger the brush. When you feel more confident, there is an array of brushes to experiment with from mop-shaped brushes to fan-shaped ones.

Paper There are many makes of paper in different weights and textures. Throughout this book I have mainly used Bockingford 300 gsm (140 lb) Not (not hot-pressed) medium textured paper. I use this weight as it doesn't need stretching, and I like to work quite wet. There are rough and smooth-surfaced (hot-pressed) papers with which you can experiment later.

Pencils I suggest that you use an HB pencil for sketching your pictures before you paint them, and 2B to 6B, which are softer pencils, for adding tone to your sketches.

White gouache This is a thick white paint, supplied in tubes, which may be used when an area of white is needed.

Masking fluid This is applied and allowed to dry before watercolour is added over the top, then can be rubbed off once the watercolour is dry to reveal the original white paper underneath. This is useful for highlights (see page 17).

A selection of papers and one of the author's completed paintings

Some of the extra items that you will find useful

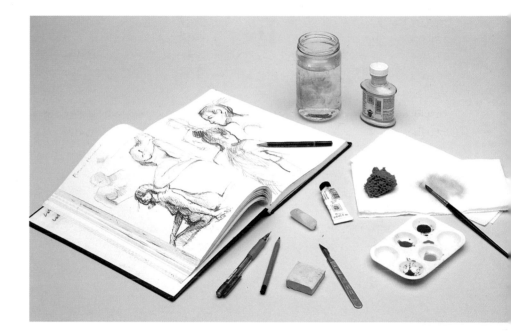

A jam jar or other container to keep your water in.

Kitchen roll This may be used to blot excess water from your brushes and for lifting out areas of wet paint (see page 18) or mistakes.

A soft putty eraser This is useful for rubbing off the pencil lines when you have finished painting: it will not lift off too much of the colour or damage the paper.

A plastic palette This will give you space to mix your paint.

A light drawing board This is useful for supporting your paper. Masking tape may be used to secure the paper to the board.

A natural sponge This may be used damp for taking out mistakes that have dried.

A candle This will add texture to your paintings. If you paint over areas where you have applied wax the wax repels the paint and leaves highlights or a dappled effect.

A craft knife This is used for scratching out highlights, and is particularly useful when painting hair (see page 17).

A small back pack This is useful if you are planning to travel with your paints.

A small stool This is handy for outdoors work.

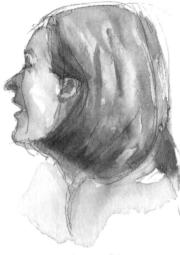

TECHNIQUES

Watercolours may be used on a surface that is either wet or dry, and the paint behaves differently on these different surfaces. On a wet surface it spreads and the effect is blurred, on a dry surface it retains the shape you have painted. I suggest that you practise using your watercolours by trying out some of these exercises, to get a feel for your paint and brushes.

Wet-on-wet

When wet paint is applied onto wet paper it drifts, and colours merge together to make other colours. The paper may be re-wetted once it has dried.

 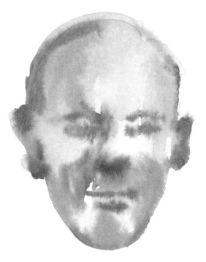

Apply two colours onto wet paper and let them drift into each other.

1 Working quickly wet-on-wet, paint the shape of a head, using the way the colours blend to show areas of shading.

2 Develop the features by adding darker paint onto the now damp surface to show the ears, eyes, nose, mouth and shading on the head.

Wet-on-dry

When paint is applied to dry paper, the edges of the shapes you paint remain sharp. The paint is allowed to dry completely before other layers of paint are added on top.

Paint a block of colour and let it dry, then add some other colours over the top. This is called glazing: you can see the colour underneath through the paint on top.

Soft edges

When painting in watercolour you often need to create a soft edge, but not one that smudges or drifts out all over the place. Soft edges are useful for painting the transition at the hairline, the planes of the face and the edge of a shadow on the body.

Alternatively, use water to wet an edge then continue with paint.

Create soft edges by running a clean damp brush (remove any excess water first) along an edge of still-wet paint.

Applying dry paint onto a damp surface makes a soft but definite mark, as distinct from an edge, and is useful for suggesting features.

Brush marks

Usually it is best to load your brush with lots of watery paint. You can make a variety of different marks by increasing or decreasing the pressure you put on the brush with your hand, and by holding the brush in different ways, either loosely towards its end, or tightly near the bristles.

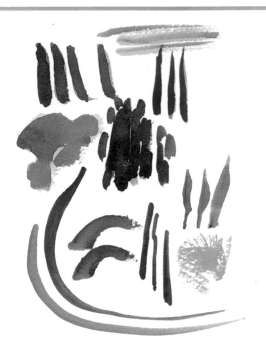

Try painting some lines, applying more weight at the start of the stroke and tailing off, then paint some curves and other marks using the heel and point of the brush. Get to know how the brush feels in your hand.

Dry brush

If you use hardly any water with your paint, the effect is feathery broken marks. Fanning out the bristles on the brush is excellent for showing hair strands.

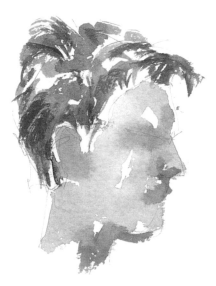

Drag and flick a dry paintbrush to reveal the surface of the paper. This makes good highlights on hair, and prevents it looking flat.

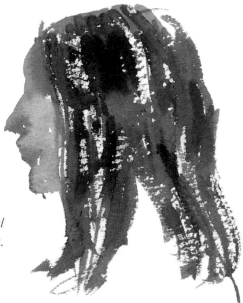

Highlights

The use of highlights in your pictures will add depth and reality. Highlights may be created three ways: by leaving white paper, by applying masking fluid to the areas you want to leave white at the start of your painting and rubbing it off when the paint is dry, or by scratching the paint out with a craft knife once it is dry.

The highlights around the girl are created by leaving white paper at the edges.

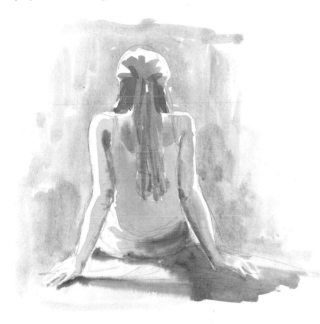

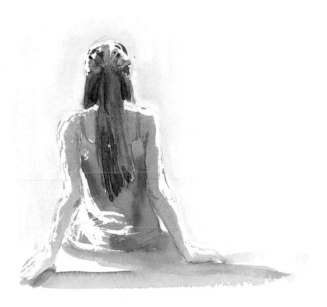

Here, masking fluid is used for the highlights before the paint is applied, and after the paint has dried the masking fluid is rubbed off to show the white paper underneath.

Scratching out areas with a craft knife once the paint is dry is excellent for showing highlights on hair.

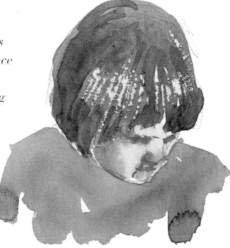

Lifting out

While the paint is still wet, areas of light may be created by 'lifting out' the paint using kitchen roll or other soft tissue. There will usually be a slight stain, depending on the colour of the paint you have lifted out. You can also use a damp sponge to lift out paint from dry paper.

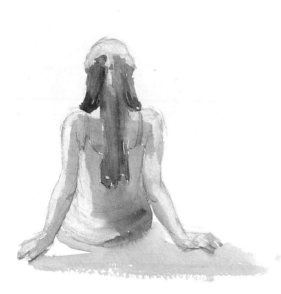

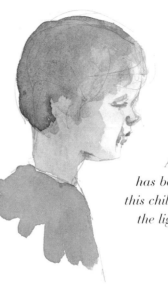

An area of paint has been lifted out on this child's face to show the light shining from the right.

The highlights around the girl have been created by lifting out an area of paint on the outsides of her arms, the tops of her shoulders and head, and the left of her body.

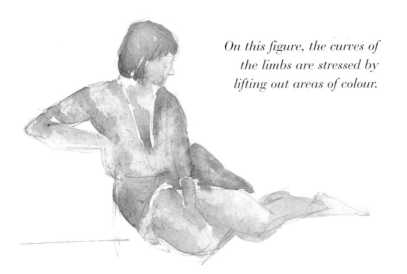

On this figure, the curves of the limbs are stressed by lifting out areas of colour.

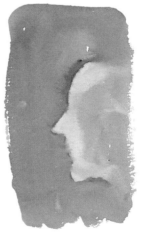

This edge has been lifted out with a brush, leaving a more definite area that shows the shape of a face.

Working from photographs

Working from photographs is ideal when you are trying to capture swift movement in your pictures. People aren't always going to pose for you. Sometimes you may see a perfect subject and have insufficient time to make a sketch of it, so taking a photograph and painting from it at your leisure is ideal. If you take a variety of photos from different angles you can select the one you like best from which to work.

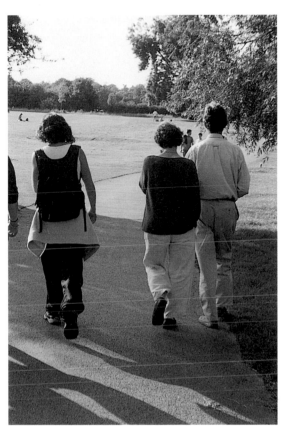

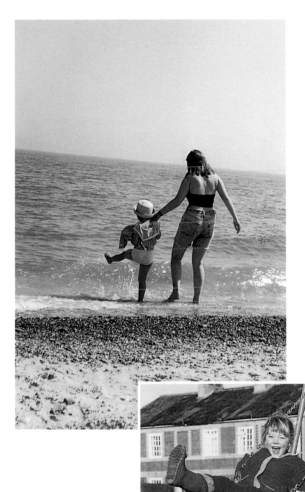

These photos have frozen fleeting moments that would be very difficult to capture in a sketch. The photos may be used to paint from at a later stage. The painting I produced from the picture above is shown on page 65.

SKIN COLOUR

Mixing skin colours comes with practice. It is a common mistake to use a mixture that looks too flat and uniform and does not enable you to show the form of the body or face. Start with diluted paint and build up to more solid areas, leaving highlights on cheeks, noses and shoulders. Stress prominent parts of the body – knees, tips of noses and chins – with warmer colours than the basic skin colour.

Asian

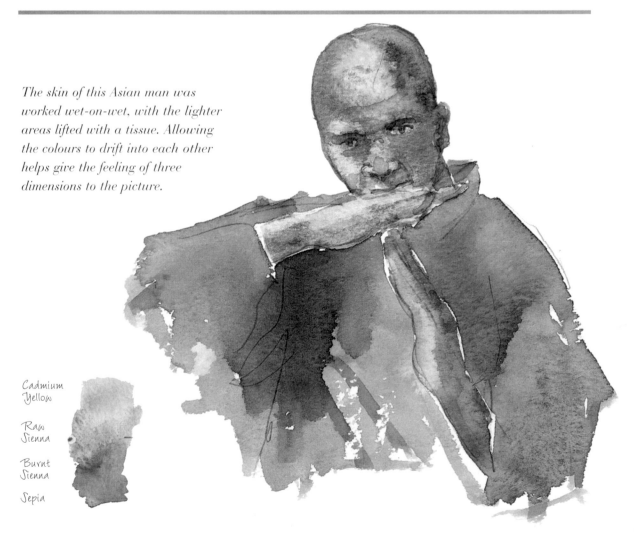

The skin of this Asian man was worked wet-on-wet, with the lighter areas lifted with a tissue. Allowing the colours to drift into each other helps give the feeling of three dimensions to the picture.

Cadmium
Yellow

Raw
Sienna

Burnt
Sienna

Sepia

African

African skin can be dark, shiny and rich with bluish-purple shadows. The highlights are very strong in contrast to the skin colour, so leave them as white paper. Again, the colours were allowed to drift into each other, and the very deep darks were added at the end when the other paint was dry.

Sepia Vandyke Violet
Brown

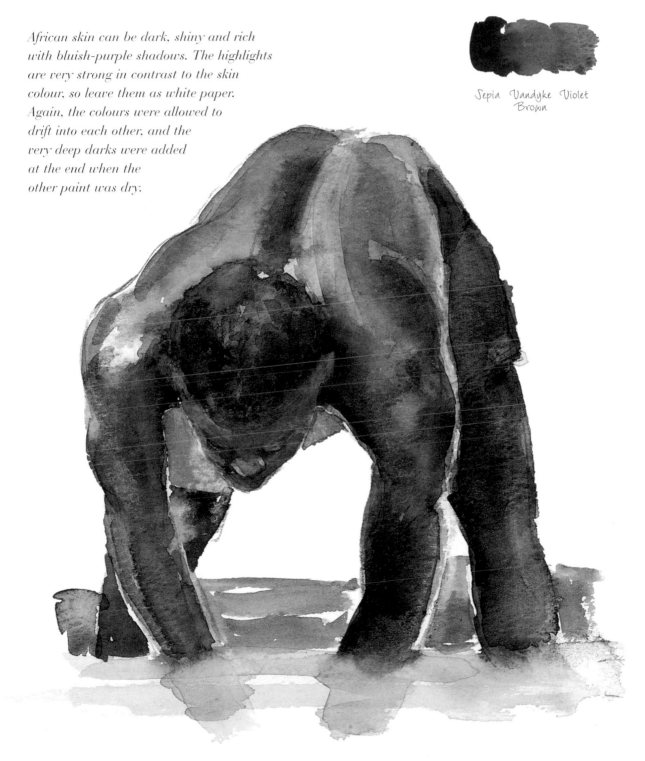

Arab

Arab skin is more brown than reddish. The leg
on the right is further back and is slightly in
shadow, so I made the skin colour less warm.

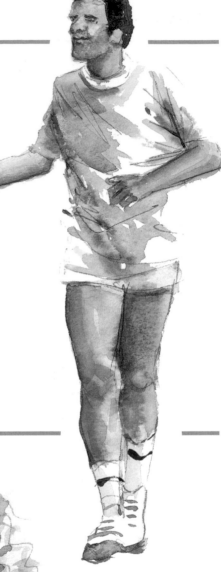

Yellow Ochre

Burnt Umber

Burnt Sienna

Mixed race

Mixed race skin can vary
hugely in tone. Here the
emphasis is yellows, and the
shadows are applied with a
very light touch.

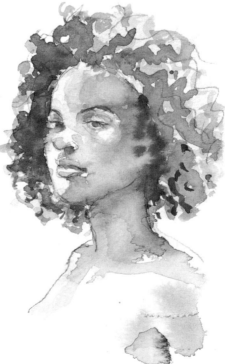

Raw
Sienna

Burnt
Sienna

Cadmium
Yellow

Sepia

White

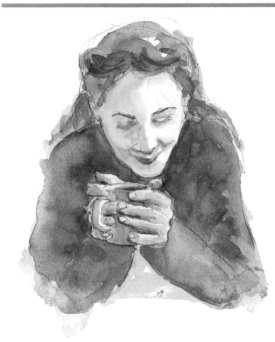

White skin has less brown in it, and the shadows tend to be more greenish-blue. This head was painted with a very light touch to keep the skin looking translucent and young. Use very diluted yellow mix as the base, then very gently add other colours to the still damp paint.

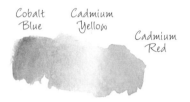

Cobalt Blue Cadmium Yellow Cadmium Red

Older skin

Older faces have more complicated planes, and the skin tone is more varied in the folds and expression lines. The light hits at different angles. Older skin tends to have warmer shadows than younger skin, and the contrasts are stronger. Older white skin is more brown and yellow.

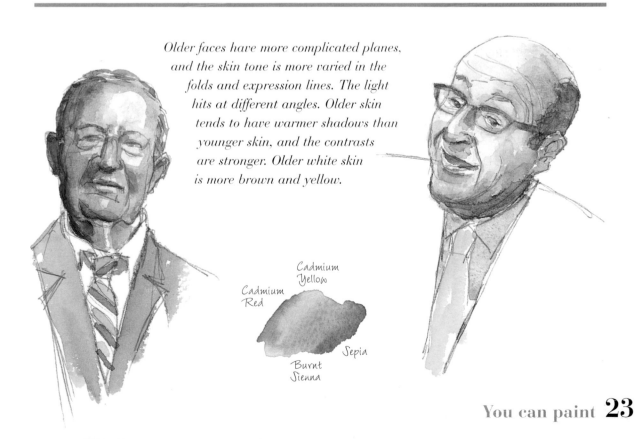

Cadmium Red Cadmium Yellow Sepia Burnt Sienna

SCALE AND PROPORTION

To get the proportions of your people right, think of them divided into parts. Stand someone in front of you. Hold out a long pencil with your arm straight and elbow locked. Line the top of the pencil up with the top of the person's head. Place your thumb on the pencil in line with the bottom of the chin. This pencil length, the head length, is your measuring unit.

Adults

The average adult human figure can be divided from crown to ankle into approximately eight head lengths. Some people have short waists and long legs etc., but these are the standard proportions.

Here the body has been divided into a number of head lengths, showing the divides at the neck, chest, waist, hips, knees and ankles. There are slight differences in the proportions of men and those of women.

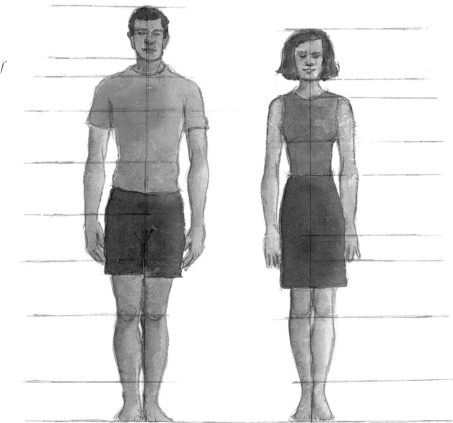

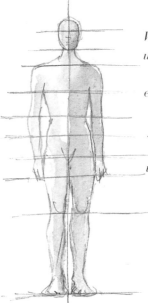

When people stand with their weight evenly distributed, the feet take the weight totally evenly. All the body parts are balanced. It is helpful when you are painting someone in this position if you put a vertical line down the middle of the figure.

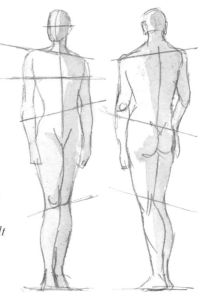

This figure has shifted its weight onto one foot by bending slightly at the knee and turning a little. The shoulders and hips tilt to compensate. People often stand with their weight unevenly distributed, particularly when they relax and bend.

Children

A child's body can also be divided into head lengths. The major difference is that the head of a child starts off big relative to the rest of his body, and grows only very gradually. As a result, a toddler has a proportionately larger head than an older child, and an older child has a proportionately larger head than an adult.

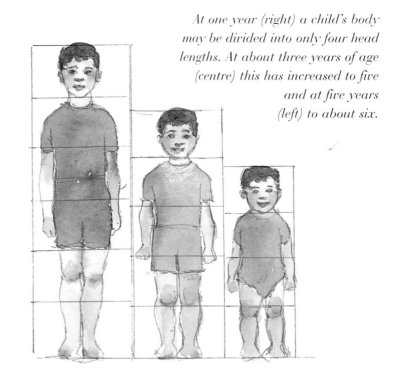

At one year (right) a child's body may be divided into only four head lengths. At about three years of age (centre) this has increased to five and at five years (left) to about six.

HEADS

It is essential to grasp the way heads move, tilt and turn on the neck if you are to paint people successfully. It is a challenge to place the features in a balanced way on the head when you are painting heads at different angles, looking up, down or sideways. It is also important to get the hair right, giving it a soft edge and leaving it as a subtle suggestion rather than adding too much detail.

Front view

The simplest view of a head is from the front. Full on, a head is an oval or egg shape, and can be divided up into sections that will help you to get the proportions correct.

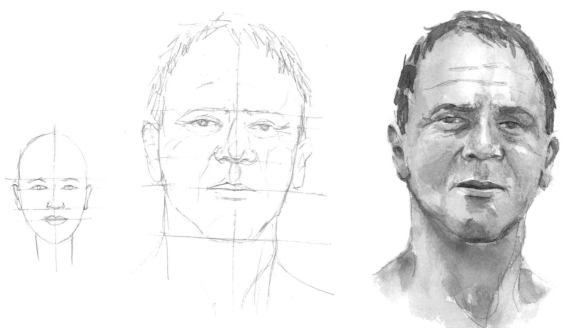

There are definite divisions of the full face when seen head on. Each face differs slightly, so there are no strict proportions. Taking a vertical line down the middle of the face and horizontals at the brows, tip of nose, mouth and chin, will help you to fill out the features correctly; and you can then go on to sculpt the head in paint. Don't forget to leave highlights on cheeks and noses, and stress the tip of the nose and chin with warmer colours than the basic skin colour.

Heads at an angle

Notice how the area of each part of the face alters depending on the angle the face is viewed from. A face looking up shows less forehead and more chin, one looking down shows more forehead and less chin. Also look at the distances from the ear to the features. These are increased when the head is turned away.

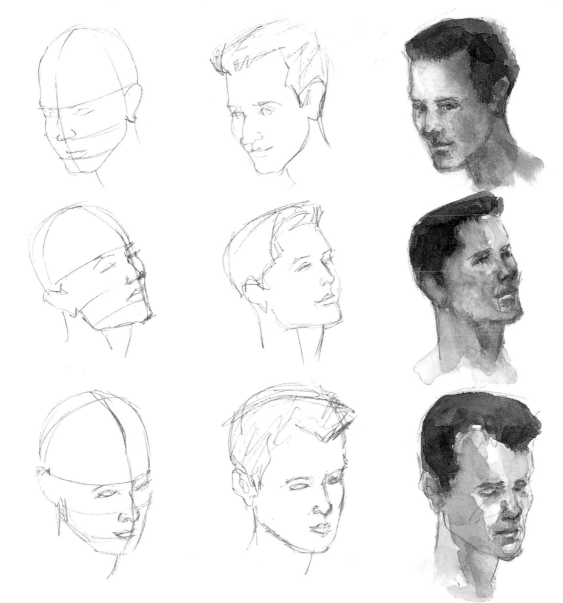

To construct the head, draw an oval and divide it into sections so that you have a middle line for the centre of the face, and draw curved lines to follow the tilt of the head on the brow line, on the nose line and on the mouth line.

Positioning the eyes

Beginners often force a partial side view of a head into almost a front view, by putting in too much of the eye that is partially hidden. There is a triangle shape formed by the eyes, nose and mouth, and it is important to keep the proportions right between these three, and check where the tip of the nose is in relation to the cheek.

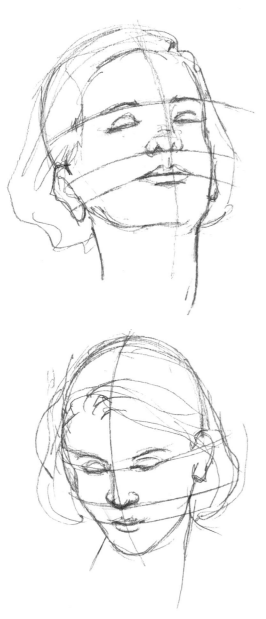

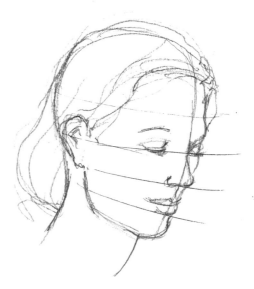

As the head turns away the eyes shorten in width but their height remains the same. The eye that is further away seems shorter than the closer one.

Man's head in profile

In profile the features are easier to locate in relation to each other. The ear is at the same level as the top of the eyebrow and the bottom of the nose. The eye is within a triangle shape.

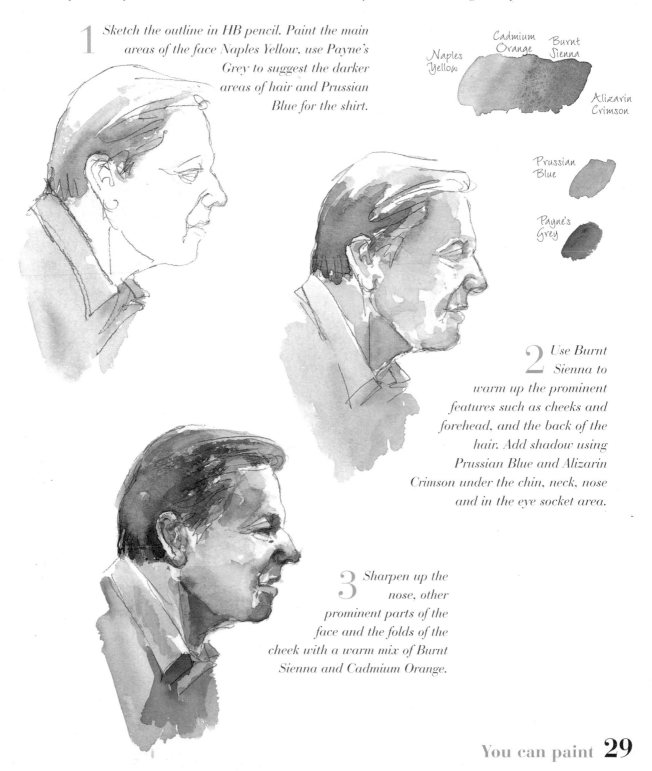

1 Sketch the outline in HB pencil. Paint the main areas of the face Naples Yellow, use Payne's Grey to suggest the darker areas of hair and Prussian Blue for the shirt.

Naples Yellow

Cadmium Orange

Burnt Sienna

Alizarin Crimson

Prussian Blue

Payne's Grey

2 Use Burnt Sienna to warm up the prominent features such as cheeks and forehead, and the back of the hair. Add shadow using Prussian Blue and Alizarin Crimson under the chin, neck, nose and in the eye socket area.

3 Sharpen up the nose, other prominent parts of the face and the folds of the cheek with a warm mix of Burnt Sienna and Cadmium Orange.

Older faces

In older faces features tend to drop, and there is less space between the nose and mouth. The triangle of features (eyes, nose and mouth) is longer and narrower. There are shadows where the skin is deeply textured.

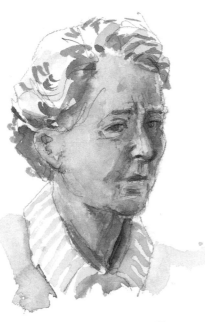

As people age their faces become less tight, mouths are less full, noses are more prominent. Generally there are more contrasts in the features and more drama and expression in the faces themselves.

When painting someone wearing glasses it is important to paint the face and the glasses at the same time, rather than add the glasses when the face is finished.

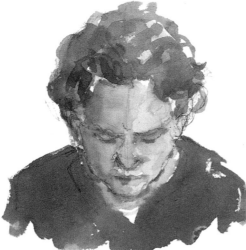

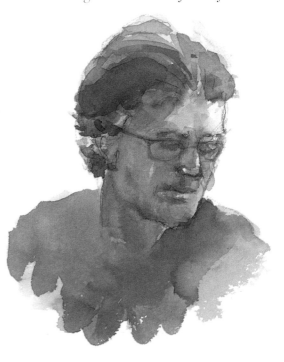

Looking down on this face the features appear to cave in a little, the jowls are loose and the jawline slack. Some frown marks can be seen.

Younger faces

In young faces the features form a wide triangle, are set apart, and there is very little shadow. Children, especially babies, need to be painted with a very light touch, leaving plenty of highlights.

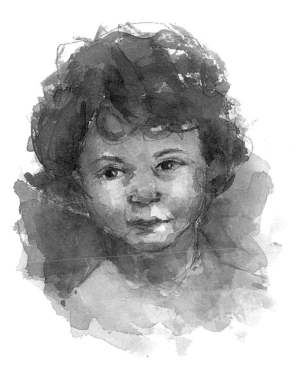

When painting children, keep the contrasts down or the children will 'age'. Warming up the end of a child's nose really helps to define the face, as there is so little definition otherwise.

Babies' faces are relatively small. The eye drops below the half way line (measured from crown to chin), and the forehead is very curved: this is especially clear in profile. The bridge of the nose is concave, and the eyes seem wider apart than adults' eyes.

Hair

Hair varies as much as skin, so think of it in broad categories such as straight, curly, wavy, grey, light, dark, fair, short or long. It is best to understate hair, concentrating on overall shapes and ensuring you give the hair soft edges, as a hard edge, especially where the hair meets the face, can be too wig-like. When the area is dry you can add a few dry brushstrokes to show texture. Be aware of the nature and direction of the light falling on the hair.

A few strands of this long dark hair have been picked out with a dry brush, the rest is a general shape with the hairline very undefined. Highlights are scratched out with a knife.

Here the brush is used in a sweeping movement onto the damp basic colour to make a heavy hang of straight, light hair.

The spikiness of short hair is emphasized by the strokes of brown made while the diluted undercolour is still damp. The marks are soft and natural.

Here lots of water is worked into damp colour to give water marks which work well to show thick hair. Drier strokes pull out the curls.

The trick with grey hair is to show its whiteness by highlighting it against the background.

Exaggerating the light reflecting on a bald head emphasizes its solidity. This can be done by lifting the paint out of an area whilst it is still wet.

EXERCISE Paint a female face

Women's heads often have soft features and the hair helps to make an interesting shape.
A three-quarters face is a very common view of a head which offers more opportunity to
express the character of the person you are painting.

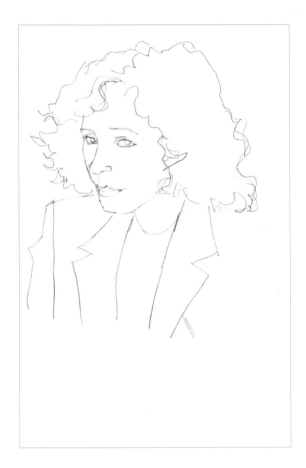

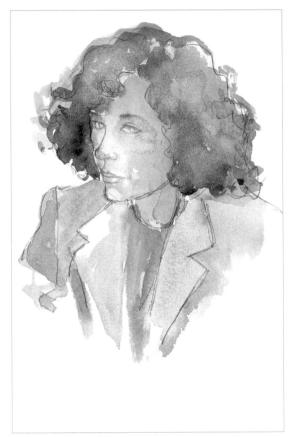

1 Sketch the face in HB pencil. Don't make the drawing too detailed. Notice the space between the nose and cheek. The eye socket is partially hidden on the woman's right side.

2 Paint a wash of Naples Yellow and Vandyke Brown for the face, wet-on-wet to blur the shadow shape on the main cheek. Paint the hair wet-on-wet using Sepia, Vandyke Brown and Cadmium Orange, and pull out some edges to define the curly shapes. Start painting the clothes in Cobalt Blue, Alizarin Crimson and Payne's Grey.

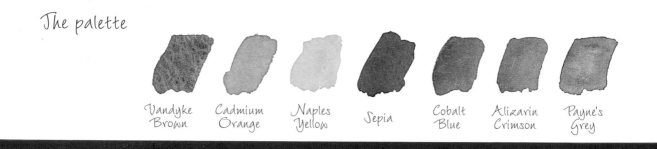

Vandyke Brown Cadmium Orange Naples Yellow Sepia Cobalt Blue Alizarin Crimson Payne's Grey

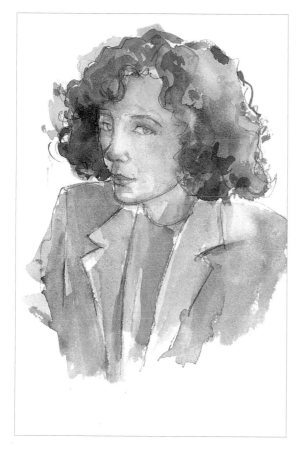

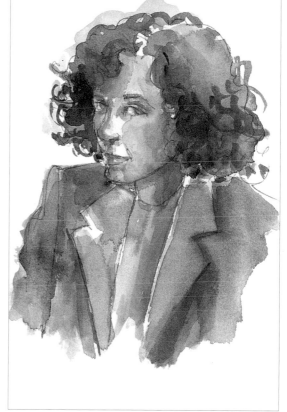

3 *Start to define the features such as the eye socket and the shadow under the nose and mouth using Alizarin Crimson. Use the same red for the lips, and a touch on the nose to project it forward. As the head is turned away the hair on the left is in slight shadow, so add Sepia to show this.*

4 *Bring in Alizarin Crimson on the forehead, face and the bridge of the nose. Warm up prominent features, leaving a highlight on the nose and upper mouth to give a sculpted three-dimensional effect. Finally add more dry detail to the hair in Sepia. Paint the eyes Cobalt Blue, and add a shadow in Payne's Grey under the collar of the jacket.*

HANDS AND ARMS

There is no mystery about painting hands, it is a matter of fitting pieces together in the correct proportions. The length of the hand is about equal to the length of the face from hairline to the bottom of the chin. The palm of a hand is concave, the back convex: hands are seldom held flat.

Basic hands

The movement of the hand starts at the wrist, which is where the bones of the fingers start, so it is best to paint a hand as one piece, the whole hand bending in line with the fingers. This series of pictures of hands shows basic positions. Note the spaces between the fingers as well as the shapes of the fingers themselves. Painted hands must look as though they could hold or cup something, not be flat and immobile.

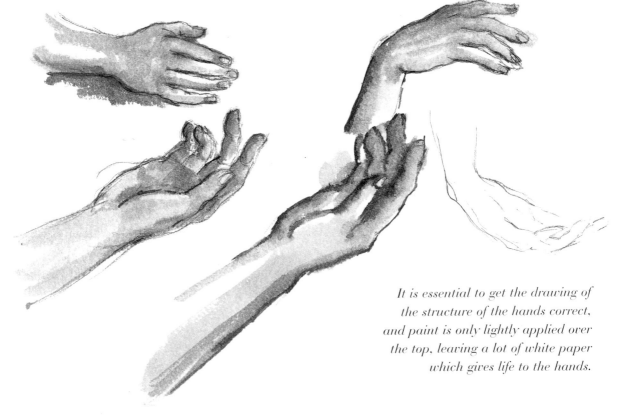

It is essential to get the drawing of the structure of the hands correct, and paint is only lightly applied over the top, leaving a lot of white paper which gives life to the hands.

Clenched hand

The overall shape of the hand is vital. and there is no need to make too much of the details such as the nails or creases in the palms.

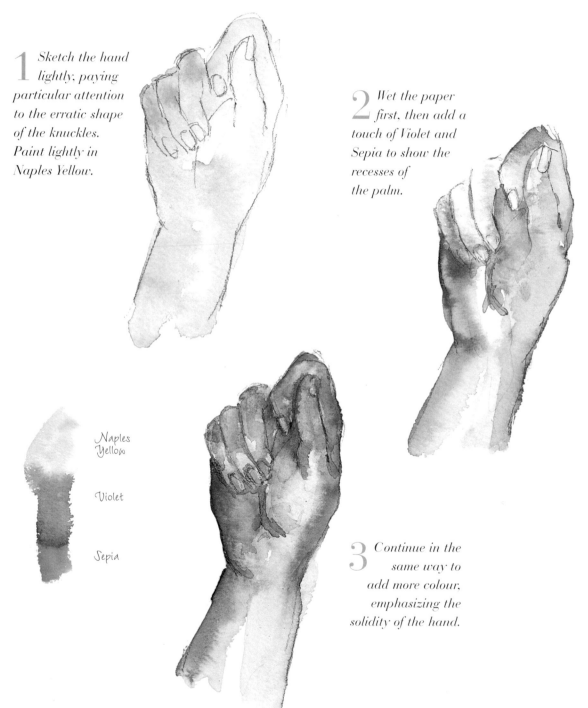

1 *Sketch the hand lightly, paying particular attention to the erratic shape of the knuckles. Paint lightly in Naples Yellow.*

2 *Wet the paper first, then add a touch of Violet and Sepia to show the recesses of the palm.*

Naples Yellow

Violet

Sepia

3 *Continue in the same way to add more colour, emphasizing the solidity of the hand.*

Relaxed hand

Here is a generous open hand, in contrast to the clenched hand on the previous page. The fingers are more outstretched and the palm is concave.

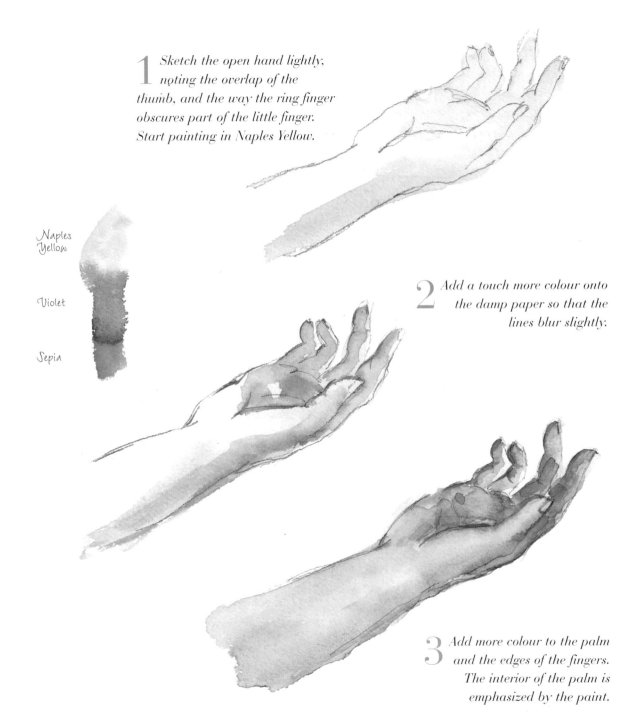

1 *Sketch the open hand lightly, noting the overlap of the thumb, and the way the ring finger obscures part of the little finger. Start painting in Naples Yellow.*

Naples
Yellow

Violet

Sepia

2 *Add a touch more colour onto the damp paper so that the lines blur slightly.*

3 *Add more colour to the palm and the edges of the fingers. The interior of the palm is emphasized by the paint.*

Expressive arms

People often use their arms and hands to express themselves. Watch how people fold their arms or hold their face with their hands.

One arm is slightly in front of the other, with a hand resting on an arm. The shadows reveal the changes in direction.

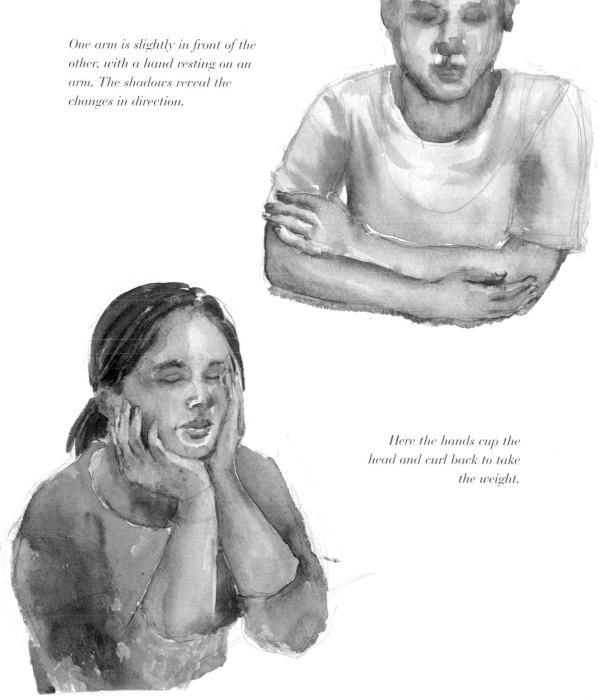

Here the hands cup the head and curl back to take the weight.

FEET AND LEGS

One of the most common mistakes when drawing feet is to underestimate the size of the foot in relation to the rest of the body, and the size of the heel compared with the rest of the foot. A person's foot is at least one head in length. Feet and legs can be as expressive as hands, and the way someone places their legs and feet when sitting can reveal a great deal about them.

Basic feet

I painted these feet from different angles and viewpoints. You may like to practise by drawing your own feet in many poses by setting a mirror on the floor. Try to see the foot as a single shape, the toes only being added at the end of the painting process.

Note the length of the toes when the foot is in profile, and the foreshortening of the foot when viewed from the front: the big toe dominates, and the heel dominates the view from the back.

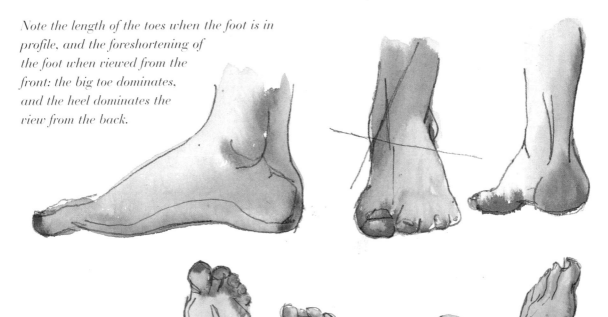

Look at the shapes of the toes when viewed from underneath, and the way the foot twists and the sole creases.

When someone is lying down, a fold appears in the sole of the foot. In movement, the toes support the weight of the feet, and the ball of the foot does the same when you are sitting.

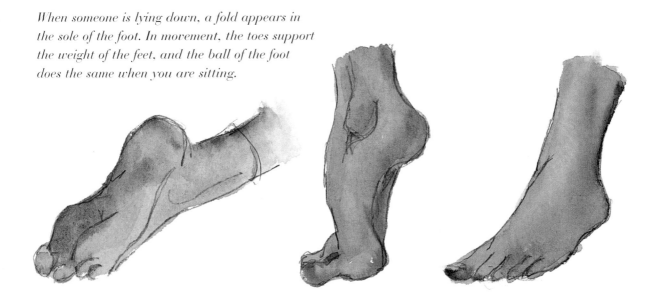

Legs

Imagine yourself sitting cross-legged in a chair: this will help you to feel where the weight is distributed. Adding trousers simplifies painting the legs.

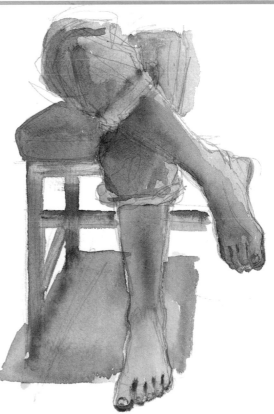

The light is hitting the boy's feet, and the legs are in purplish shadow. This helps to create the sense of the foot being placed firmly on the ground.

Shoes

There is an enormous range of shoes, and they can add character and individuality to your people. Practise painting your own feet by looking in a mirror.

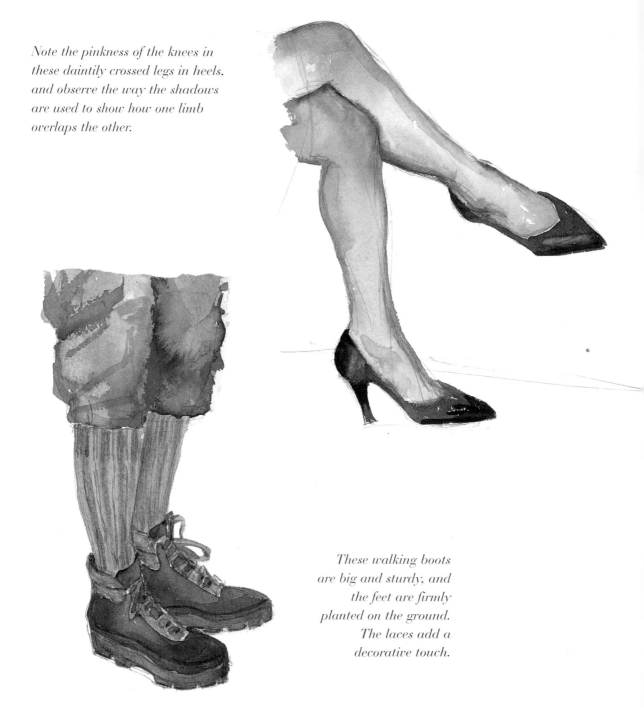

Note the pinkness of the knees in these daintily crossed legs in heels, and observe the way the shadows are used to show how one limb overlaps the other.

These walking boots are big and sturdy, and the feet are firmly planted on the ground. The laces add a decorative touch.

The trainers are on the legs
of a young, confident man,
and the way the feet are
casually tilted gives the
picture a sense of
atmosphere. Notice the
way the trousers fall over
the ankle.

One of the legs in sandals is
painted slightly bent as if
anticipating a dance: here I
focused on the way the strap
curve alters depending on the
angle of the leg.

SINGLE FIGURES

It is good practice to start by painting a friend, or yourself (using a mirror), so that you become familiar with the general proportions of the human body and know how it looks when standing and sitting. Don't be too ambitious at first, and try sketching a number of different poses before you begin to use your paints.

Nudes

Sketching nudes is a good way to begin painting people. You will gain a better idea of the form and shapes of the human body, which will help you when you are painting people fully clothed.

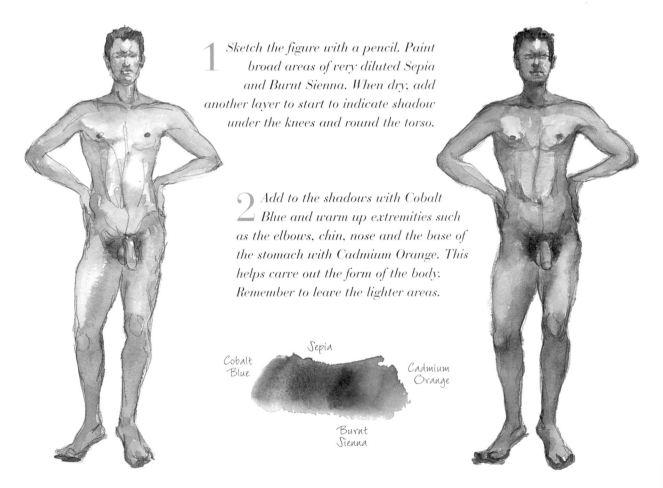

1 *Sketch the figure with a pencil. Paint broad areas of very diluted Sepia and Burnt Sienna. When dry, add another layer to start to indicate shadow under the knees and round the torso.*

2 *Add to the shadows with Cobalt Blue and warm up extremities such as the elbows, chin, nose and the base of the stomach with Cadmium Orange. This helps carve out the form of the body. Remember to leave the lighter areas.*

Cobalt Blue

Sepia

Cadmium Orange

Burnt Sienna

The darkness around this figure emphasizes the rim of light on the body.

Here the background shapes give form to the front of the body.

This picture is mainly a sketch with just a touch of paint and very little detail.

This figure is in a very relaxed pose and the fluidity of the painting reflects this.

EXERCISE Paint a single figure

This person is standing in a relaxed manner with one leg slightly bent and one hand on her hip. The body is slightly twisted, so the centre plumbline is pushed round, and as the weight is slightly unevenly distributed, one hip is tilted just above the other.

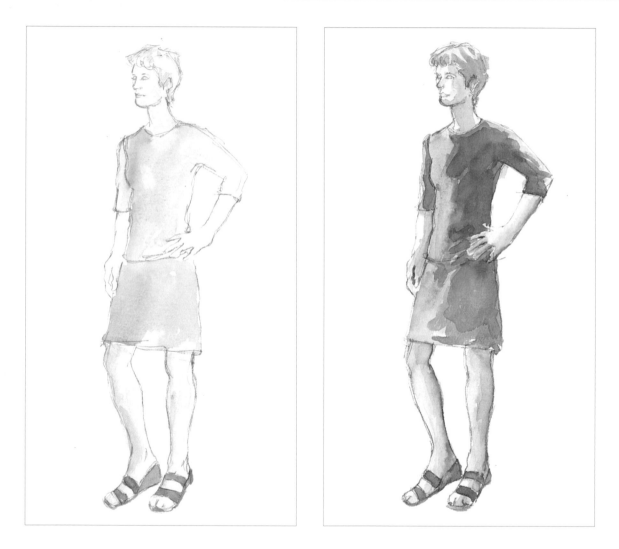

1 *Sketch the outline of the figure in HB pencil, then apply a wash of very diluted Cobalt Blue for the clothes, and Naples Yellow for the skin tone. The sandals are painted on in diluted Sepia.*

2 *Paint in the shadow on the clothes with an overwash of blue with a touch of Violet and Payne's Grey. Once dry, add the same mix on top, leaving the edges of the first shape. Burnt Sienna is used to contour the limbs.*

The palette

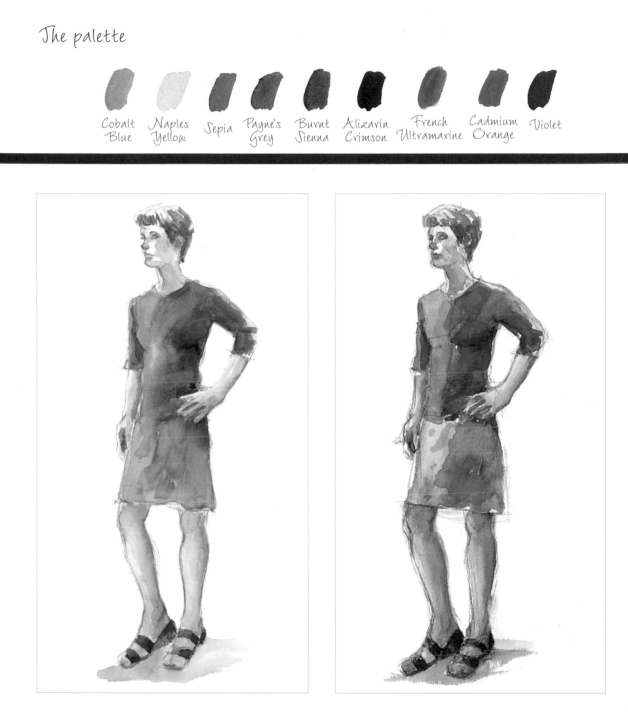

Cobalt Blue Naples Yellow Sepia Payne's Grey Burnt Sienna Alizarin Crimson French Ultramarine Cadmium Orange Violet

3 *Paint the hair with short strokes of Sepia and the face with Burnt Sienna, Alizarin Crimson and Cadmium Orange to sculpt the head. Wet the shapes before adding the paint to give more contour, rather than a hard line.*

4 *Increase all the tones and add the details, such as the shadows between the fingers, the shadow cast under the neck and the eye socket. Try not to cover the highlights (white paper) on the cheek and nose.*

Sitting figure

Now try painting a figure in profile sitting down. The shape is very definite. Notice the shapes that the background forms in the gaps in between the parts of the body.

1 *Sketch the outline, then paint the face and arms in Naples Yellow, adding Cadmium Red for emphasis. The clothes are Payne's Grey and Violet, the stool Raw Sienna and Payne's Grey, and the hair Burnt Sienna.*

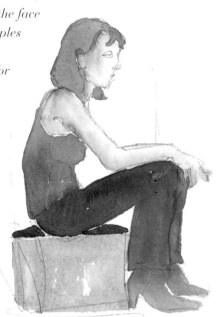

2 *Paint the square shape behind the figure Cadmium Red. Increase the flesh tones and colours of the clothes with the same paints as before. Add a touch more Burnt Sienna to the hair.*

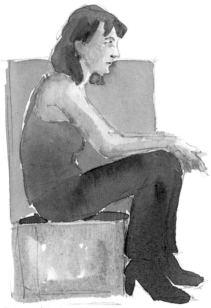

Naples Yellow

Cadmium Red

Payne's Grey

Violet

Raw Sienna

Burnt Sienna

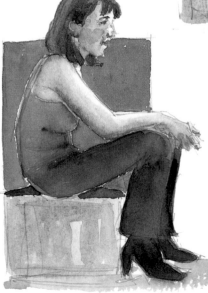

3 *To complete the picture, increase the intensity of all the colours, and use a dry brush on wet paint to add the folds on the body. Add just a suggestion of the facial features.*

Foreshortening

When someone sits hunched up. lies down or curls up. their limbs can seem to be distorted or even disappear. This effect is called foreshortening. Paint exactly what you see. however peculiar the shapes may seem: don't invent and force a limb to be more rational as your picture will not be convincing. Sometimes it is best even to exaggerate the difference in scale if a limb is near to you.

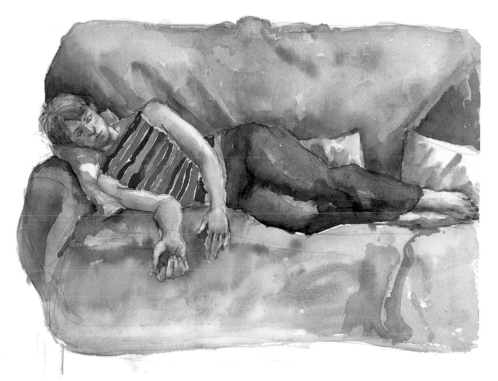

The figure is dozing, so the arms and legs are in a natural position. The legs are slightly bent and the arms have flopped. See how the arm is foreshortened and the hands seem large as they are nearer to you. I exaggerated the size of the hands slightly to emphasize this point.

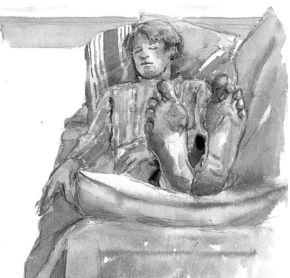

In this picture I was close to the feet, so they appear enormous. I had to check the measurements and proportions as I didn't quite believe my eyes, but they were correct! This is extreme foreshortening.

Figure on sofa

This shows how strange limbs can look when folded under each other and when stretched out. Using the principle of measuring limbs against the standard measure of a head length, the proportions will appear fine. The woman has crossed her legs so the lap seems to disappear and the underneath leg seems very short. The stretched out arm is as long as the knee to foot length of the top leg.

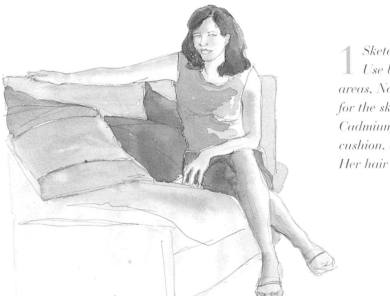

1 *Sketch the picture in HB pencil. Use broad washes in the main areas, Naples Yellow and Burnt Sienna for the skin, Permanent Rose and Cadmium Red in her top and the cushion, and Payne's Grey for the sofa. Her hair is painted in Sepia.*

2 *Emphasize the shadows on the limbs with a mixture of Burnt Sienna, Cadmium Red and Sepia, leaving the side that is lit clear. Add more grey to the sofa and Sepia to the cushion in the areas in shadow as well as wet-on-wet for the pattern on the other cushion.*

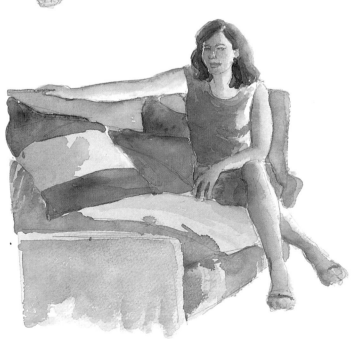

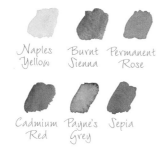

Naples Yellow Burnt Sienna Permanent Rose

Cadmium Red Payne's Grey Sepia

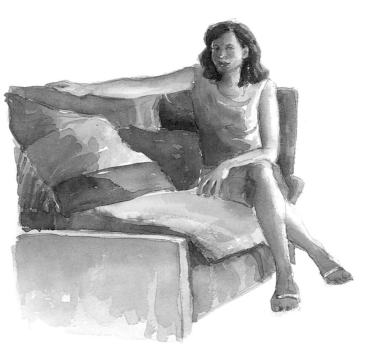

3 Define the figure by using the grey more crisply round the shape of the body. Define the features with more flesh tone colours, leaving the light on the face. Add a touch of white gouache for highlights on the nose and mouth, and lastly add Cadmium Red to the woman's top and one of the cushions.

Man sitting

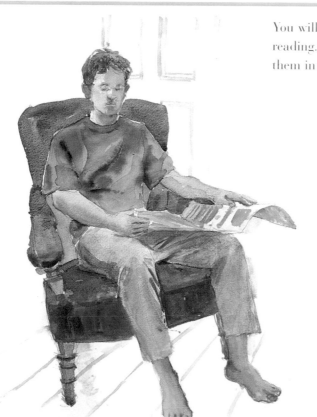

You will often find your family or friends sitting reading, and this is a good position to paint them in as they are likely to stay still for you!

Here the man is simply sitting in an armchair, so the only foreshortening is in the legs and arms. Observing the shapes in between the limbs and the legs of the chair is helpful when you are deciding where to place the figure.

Different viewpoints

Where you are in relation to the figure makes a real difference to the finished picture, so be aware of your position when you are painting. Are you looking down, or on the same level? Always check proportions, especially with complicated positions. Here I have shown two images of the same figure sitting on the ground, painted from slightly different positions. I chose to look at the figure with her head turned away, making it easier to paint her and the image more evocative.

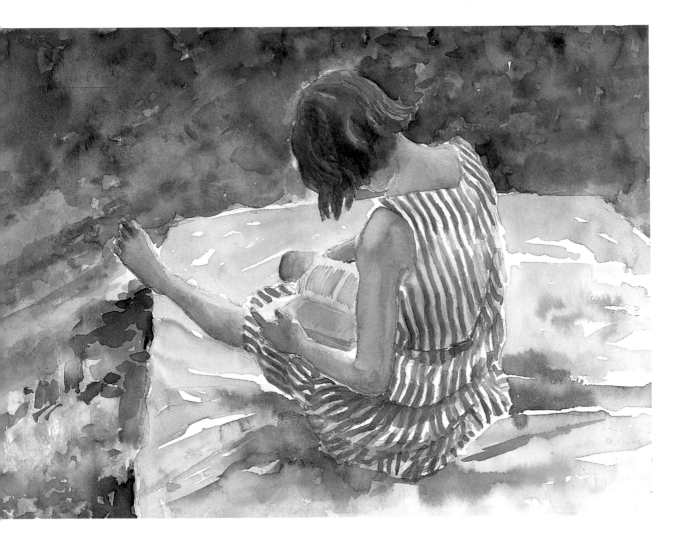

Note here the way the stripes change direction following the way the back is bent. This view from above shows a lot of grass, filling the space and balancing the rectangle of the cloth. The light is on the back of the neck: it is early evening summer light so the colours are warm.

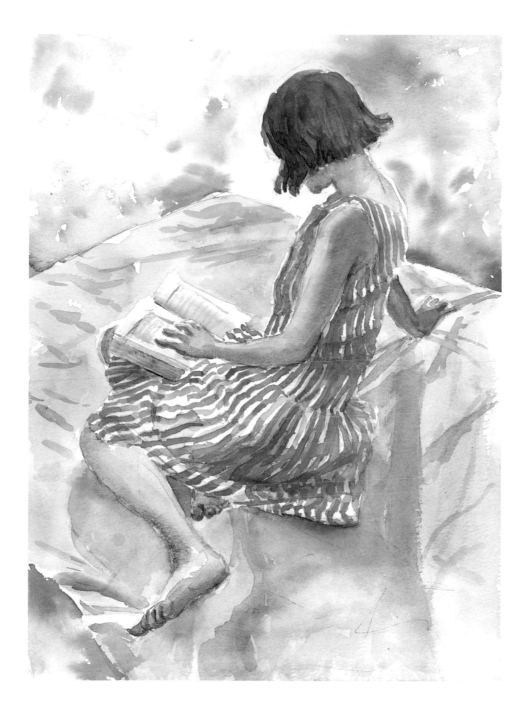

Here there is emphasis on foreshortening, as the figure is leaning on one arm and her foot is tilted upwards. The cloth is at a different angle because I altered my painting position, but it still fills the space well.

AT A GLANCE...

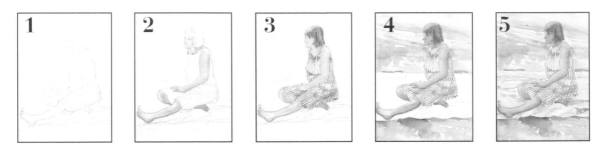

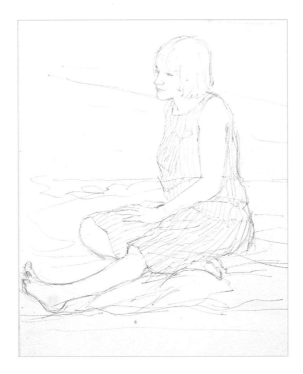

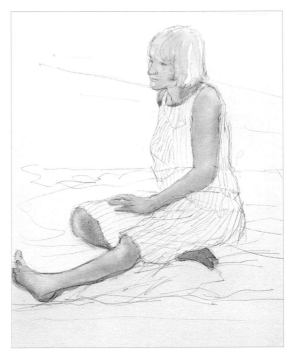

1 *Using an HB pencil, sketch the girl loosely to emphasize the direction of the stripes on the dress, which help give the impression of the figure sitting down on the ground.*

2 *Using a big brush, carefully flood the areas of the limbs and head with water. First drop in Naples Yellow and then, as the water slightly evaporates, add Burnt Sienna where the head and limbs are slightly in shadow and need to look solid.*

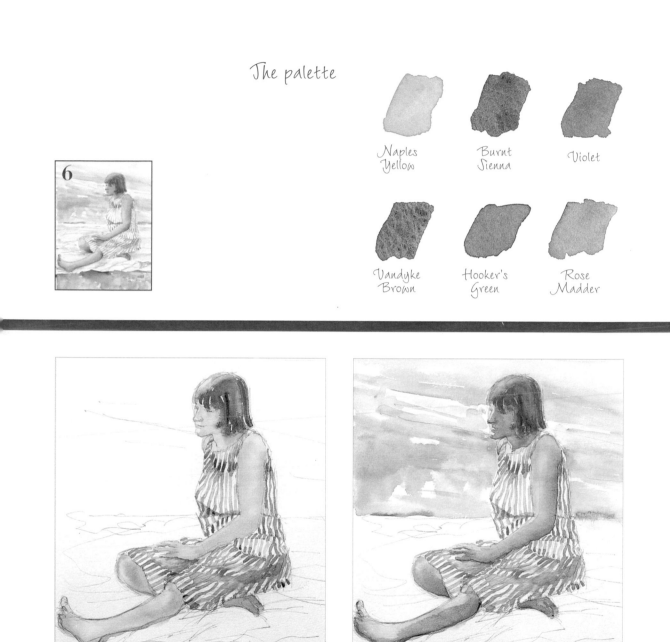

The palette

Naples Yellow

Burnt Sienna

Violet

Vandyke Brown

Hooker's Green

Rose Madder

3 Using *Violet* paint with a smaller brush follow the stripes to the folds, adding slightly more paint to the wet colour where the folds create shadows and the colour appears more intense. Use *Vandyke Brown* for the hair, leaving a band of light on the top of the head.

4 Using the bigger brush, paint the grass areas with *Hooker's Green* and *Naples Yellow* wet-on-wet. Add more *Burnt Sienna* and *Vandyke Brown*, wetting the inside of the arm to give a subtle transition from light to dark. Add shadow across two-thirds of the head, leaving a sliver of light at the edge of the face.

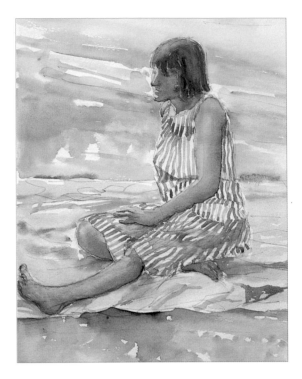

5 *Still using the bigger brush, add Rose Madder to the blanket, wetting the paper first. Emphasize the creases by leaving white paper where the light hits the top of the folds.*

Detail: Watch how the stripes change direction, following the folds of the dress.

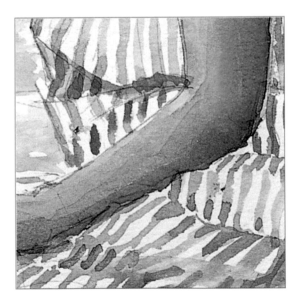

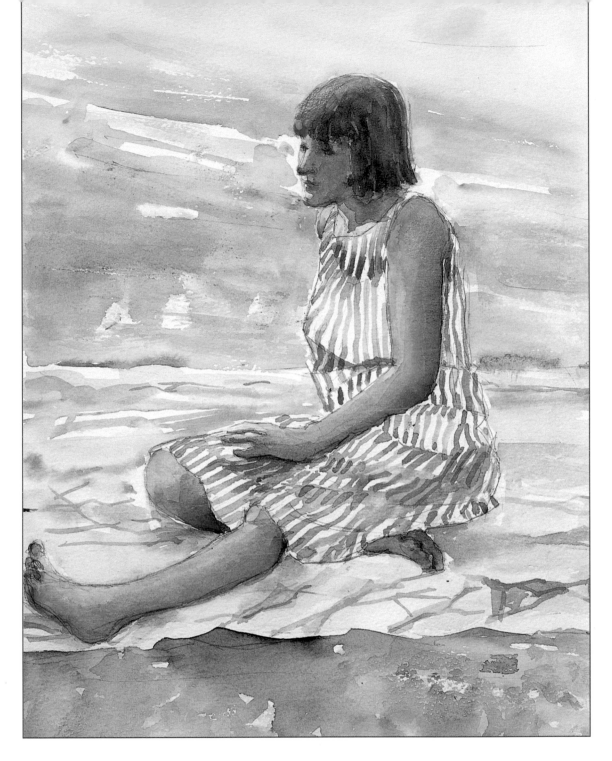

6 *Finished picture:* Bockingford 300 gsm (140 lb) Not paper, 38 x 28 cm (15 x 11 in). Use candle wax to add texture on the grass, and paint over with more Hooker's Green. The candle wax will resist the paint.

Increase the shadow on the arm by adding a touch of Violet: this will reflect the colour of the dress and bring the picture together. Using your smaller brush, add some detail to the facial features, keeping your touch very light.

LIGHT

When painting, the source of the light is vital, whether it is natural or artificial. At first it is best to paint subjects that are lit from one side. Good contrast helps to capture form. Look for the lightest area and the darkest, then the tones in between. The most effective way to see the tones is to half shut your eyes, as this will eliminate the detail and you should be able to see in basic blocks of tone.

Contrejour

Contrejour or back lighting is when a figure is against a light source, the most common example being someone set against the light coming in from a window, without an artificial light inside the room. Most of the subject is in shadow, making details hard to see.

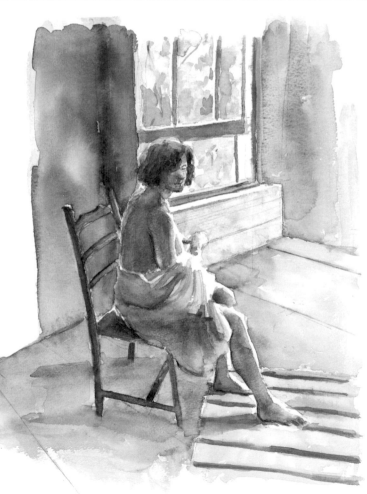

The back lighting on this figure gives a rim of light right along the edge of the body, which has been left as white paper.

1 *Sketch the outline of the head and shoulders with an HB pencil.*

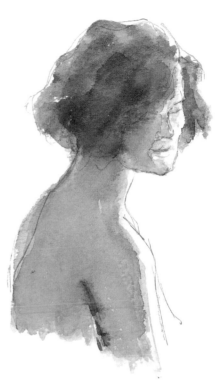

2 *Paint the hair and body in strong colour, leaving white paper to show the rim of light on the body.*

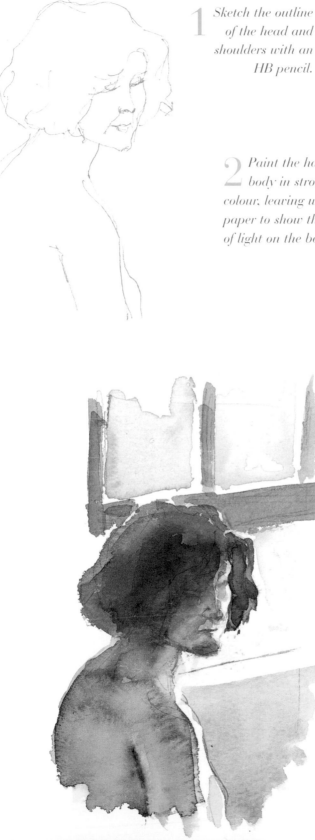

3 *To stress the rim of light and the back lighting, add a window as the source of the light, again leaving white paper to show the highlight.*

Cadmium Red, Violet and Sepia

Raw Sienna

Naples Yellow

Light from one side

The advantage of lighting from one side is that features and details tend to disappear. making the painting much easier and more effective. The examples here are practically silhouettes.

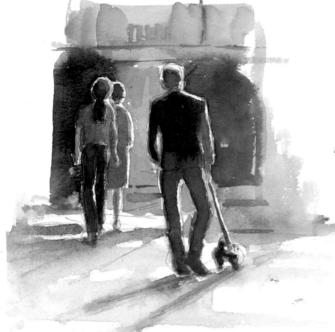

Concentrating on the backs of your subjects leaves more to the imagination and makes painting easier. Also if you are painting on the spot. by painting people from behind you will be less invasive and are less likely to be noticed, so this is a good view to start with.

This painting illustrates how much can be shown about the light on a bright beach scene by the shadows on the back of the girl. You can also see the shadow of her body falling across the towel on which she is sitting. Although the face of her companion is showing, the features are not very detailed.

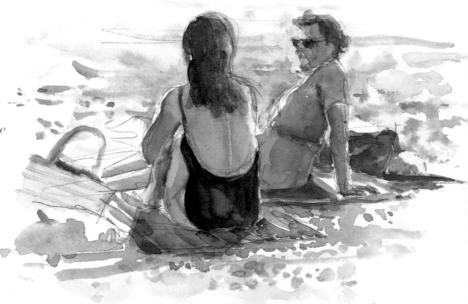

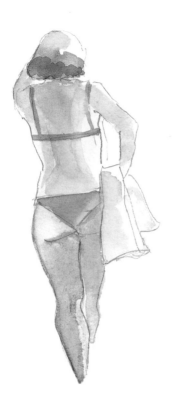

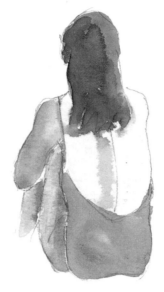

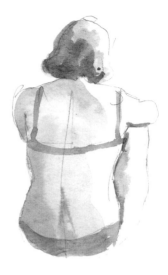

These figures have been isolated out of context to show the first stages in the layering of paint. I put in the really cooler shadows onto their backs when the paint was completely dry.

Here two of the figures above can be seen in the context of the entire picture. Notice how the standing girl is emphasized by the green shapes of the trees in the background.

Diffused light

I painted this couple with the light from one side being filtered through the trees. Remember to hold back on the light areas, leaving the paper exposed. Only the planes of the faces were painted, not the features.

1 *Begin painting using Sepia and Prussian Blue very diluted to pick out the main shapes and the dappled shadow. The painting at this stage is very 'tonal'.*

Sepia Prussian Blue

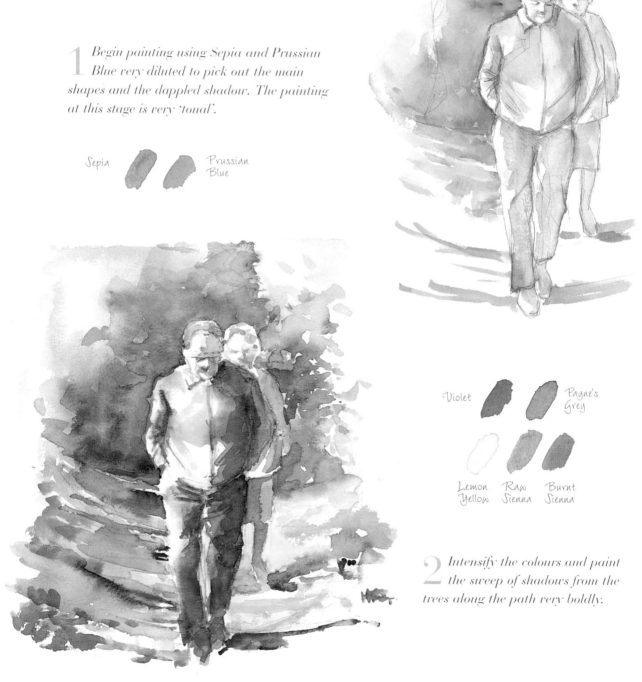

Violet Payne's Grey

Lemon Yellow Raw Sienna Burnt Sienna

2 *Intensify the colours and paint the sweep of shadows from the trees along the path very boldly.*

Leaving white paper

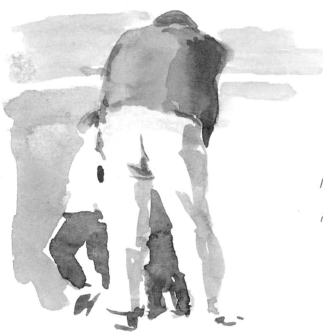

When figures are in extreme directional light it is very important to leave white paper as a contrast to the painted areas.

In this picture I have essentially painted the surrounding shapes. The children are painted in to give the impression of the adult's legs without the legs themselves being painted.

Midday sun

Midday sun. when the light is from overhead. tends to bleach colours and flatten the subject. and the shadows formed are only slight.

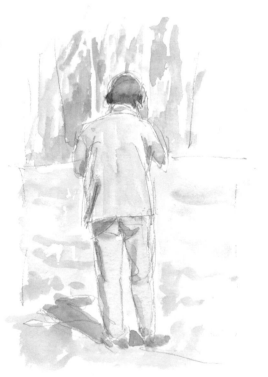

This was painted very quickly because the light can change quickly at this time of day, and because the man was on a mobile phone and was unlikely to stay in this position for very long.

GROUPS

People are often seen in groups, so it is important to learn to put your figures together. Watch how edges overlap and look at the spaces in between and the 'negative' shapes that are formed. Watch how people interact, how their bodies lean forwards when they talk, and how people walk on a path together. Experiment with the way you place your group of figures in your rectangle of paper.

Figures with geese

The focus of this picture is on the action, so I homed in on a small section of the view, concentrating on the overlapping figures.

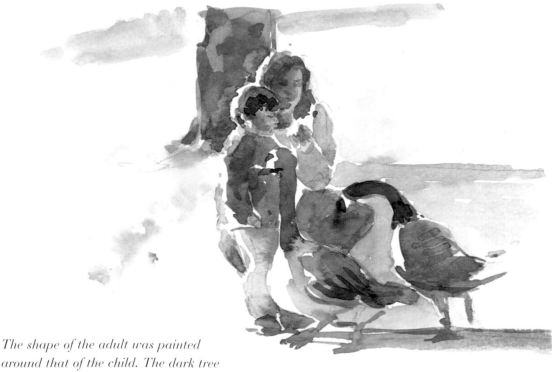

The shape of the adult was painted around that of the child. The dark tree trunk helps stabilize the figures, and a rim of light (white paper) is left on the figures' backs.

Walking group

When drawing people walking it is important to focus on the position of the feet and legs. You will soon get familiar with how figures move and the way they slightly overlap each other, or the gaps between them.

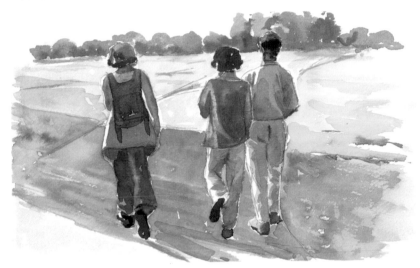

The spaces between the figures and the curves of the path make for a well-designed painting. Even simple situations can offer painting opportunities.

People in café

Another quite ordinary scene, and it is the way one figure obscures another that makes this so believable.

It is brighter away from the group, so they are painted quite dark, almost as silhouettes. There is light on the tablecloth. The feet are placed carefully in relation to the chair legs.

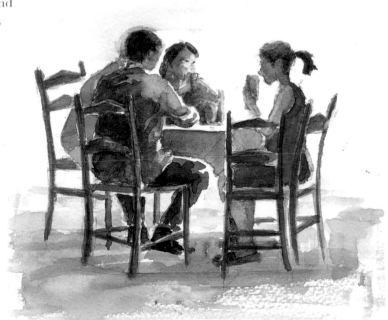

Rock group

I used a photograph to sketch from, as the group was only there for a short time, and I wanted to catch a moment of action.

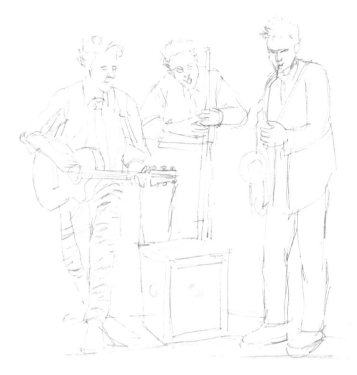

1 Sketch the details in with an HB pencil, capturing the position of the hands in relation to the instruments.

2 Paint the suit, the shadow and a few details in Payne's Grey. Other clothes are French Ultramarine and Prussian Blue, with an orange mix for the trousers and tie. The hair is Raw Sienna, Vandyke Brown and a touch of Payne's Grey, and the shoes Lemon Yellow.

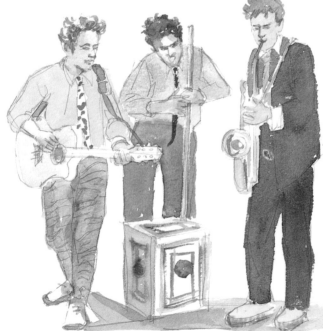

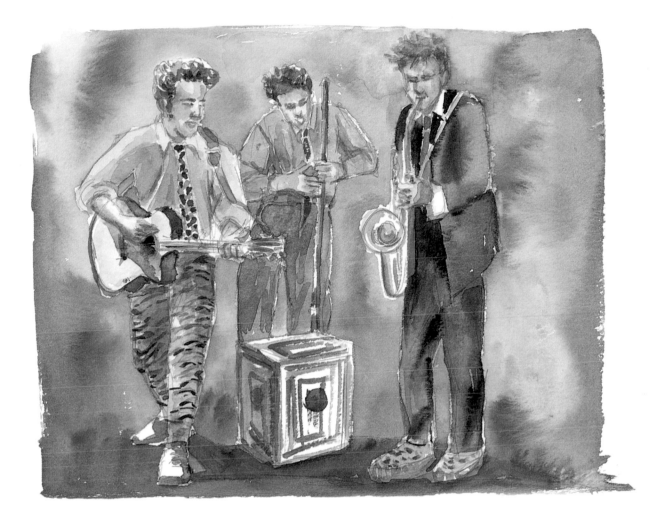

3 *Add fine detail to the tiger skin trousers in Payne's Grey, and to the tie in Cadmium Red and Payne's Grey. The grey is also used to intensify the colour of the suit. The shadows on all the clothes are added, and the background painted in reds and yellows.*

Payne's Grey

Prussian Blue

French Ultramarine

Alizarin Crimson

Cadmium Red

Cadmium Yellow

Lemon Yellow

Raw Sienna

Vandyke Brown

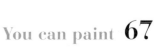

Group in boat

This scene really integrates the figures with the action. The challenge is to make the boat on the water look convincing. The position of the group of figures, slightly out of the rectangle of the picture, stresses the water.

1 *Sketch the scene in HB pencil with emphasis on the water. Ensure that the distant waves are smaller marks than the reflections and ripples in the foreground, to create a sense of distance.*

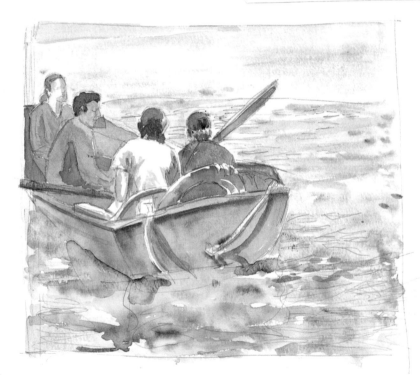

2 *Wet the paper, throw in lots of blue, and before it dries make the ripple marks with drier paint, some in Burnt Sienna and some Raw Sienna and Cadmium Yellow so that the reflection underneath the boat merges with the water. Once the paper is dry, paint in the figures and the boat.*

3 Strengthen all the colours, paying
particular attention to the shadows from
the ropes and ensuring that the most intense
colours are in the reflections under the boat.

Payne's
Grey

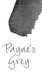

French
Ultramarine

Prussian
Blue

Alizarin
Crimson

Burnt
Sienna

Raw
Sienna

Cadmium
Yellow

DEMONSTRATION BEACH SCENE

AT A GLANCE...

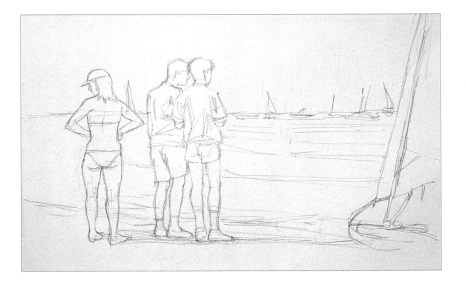

1 *Draw the figures on the beach loosely using an HB pencil. I was attracted by the way two of the figures were looking in one direction and the other in the opposite. This added tension to the picture.*

2 *Wet the paper with a big brush, then drop in Naples Yellow and Raw Sienna for the beach and Prussian Blue and Cobalt Blue for the sky.*

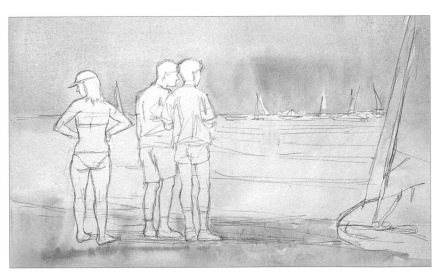

The palette

Naples
Yellow

Raw
Sienna

Cadmium
Yellow

Cadmium
Red

Burnt
Sienna

Sepia

Payne's
Grey

Prussian
Blue

Cobalt
Blue

Emerald
Green

3 *Using the same blues as for the sky, add a touch of Emerald Green and paint in the sea. Leave to dry. With a smaller brush, paint the skin tones with Naples Yellow, Raw Sienna and Burnt Sienna. Paint the hair in Sepia and the figure on the left in Naples Yellow.*

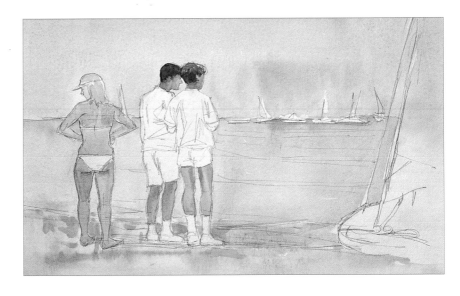

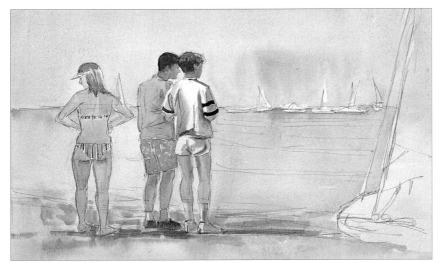

4 *Paint the bikini, socks, shoes, shorts and T-shirts. Add shadow to the white figure with Payne's Grey. Use the same green and blue for the clothes as the sea, and Cadmium Yellow. Add shadow under the figures in browns, dampening the edge of the marks to soften the shapes.*

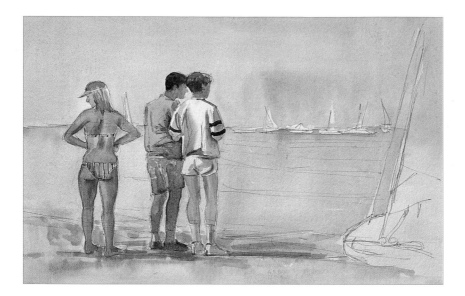

5 Increase the colours in the details of the
skin tone and hair, and on all the clothes.
Stress the shadows on the limbs to make them
look more solid.

Detail: Notice the
way the two men
overlap and their
heads are leaning
together, and look at
the shape of the piece
of sky in between
their two heads.

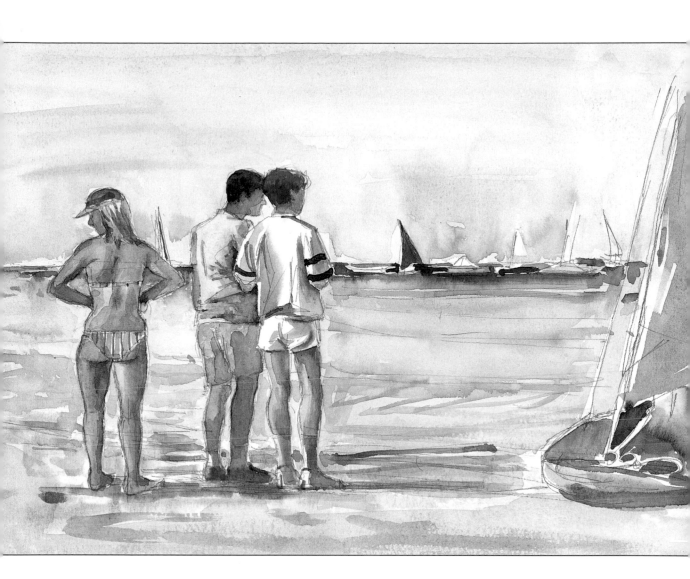

6 *Finished picture: Bockingford 300 gsm (140 lb) Not paper, 28 x 38 cm (11 x 15 in).* Add dark details in the foreground on the sand, broken marks in browns, and in the background sea using blues and greens. The horizon line, to which the figures are looking, becomes the focus of the picture. With a smaller brush add some Payne's Grey to give the impression of reflections and waves. Lastly add a touch of Cadmium Yellow and Cadmium Red to the boats.

MOVEMENT

People move all the time, so the next skill to acquire is capturing motion in your painting. When you start, a camera can be very useful to freeze action and help you to understand what is happening in the movement. Most movement involves repetition of the gestures made with the limbs, and in time you will learn to recognize the changes of positions in the figure.

Centre of gravity

Movement such as walking and running is a controlled loss of balance. As we step forwards, the centre of gravity of our body is moved forward, we lose our balance for a split second and our leg moves from behind to catch us.

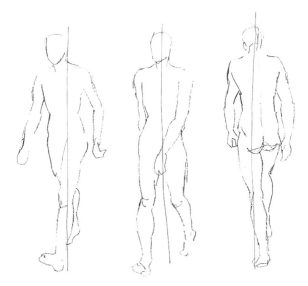

The main line of balance should lean in the direction of the movement.

If you want to draw a person in motion, place the balance point slightly ahead of the direction of the movement, so that it shows the body at that critical point when it is slightly out of balance. Then the figure will look as if it is caught in motion.

If the movement is graceful, the figure may be built on curved lines.

Conveying movement

These sketches of a figure skipping, throwing, dancing, swimming, skating and running show how little detail is needed to convey the gesture. Action is best expressed at extremes of stride, and remember always to tip the line of balance.

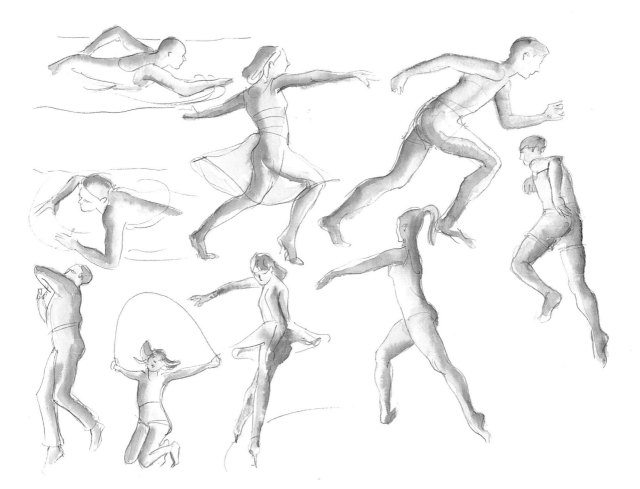

- *Arms move in the opposite direction to legs.*

- *The back foot does not leave the ground until the front foot has been put down.*

- *Arms pass the hips at the same time as the knees pass each other.*

- *The hip is higher on the side of the foot that is carrying the weight of the body.*

Walking

Walking is a gentle movement. These figures show the walking process in profile, from the side and from the front. You can paint a person walking to add interest to a street scene.

Notice in particular the changes in the angles of the knees, the twisting of the torso and the swing of the arms. Also, when seen in profile, note the way the heel lifts as the toe goes down.

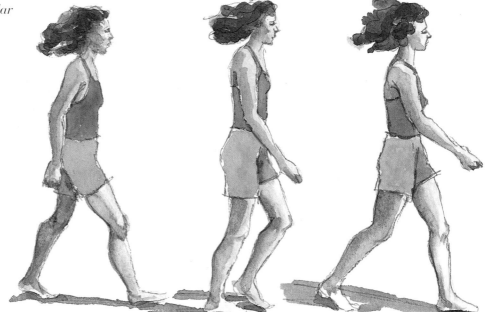

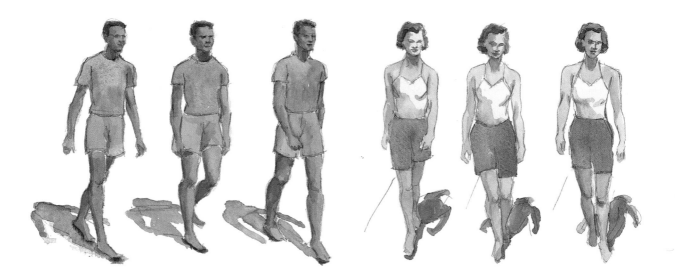

Running

Like walking. there is repetition of the stages of the movement when someone is running. but the movement is more extreme and it is important to convey the motion.

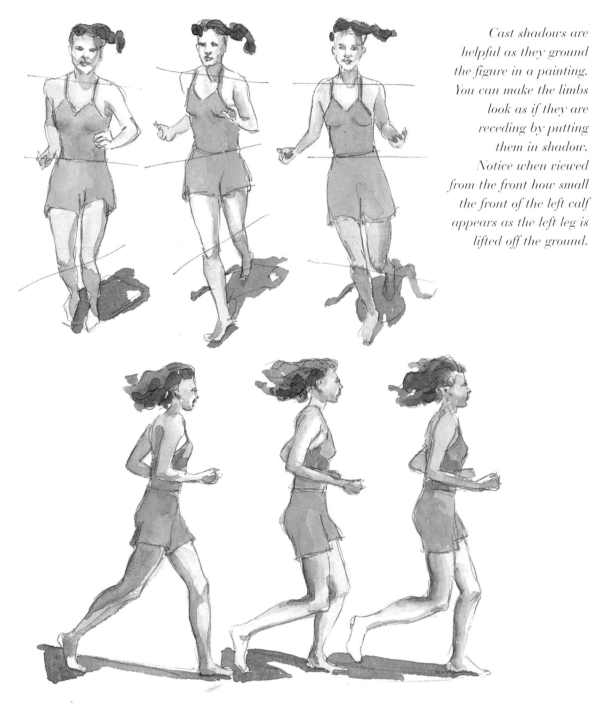

Cast shadows are helpful as they ground the figure in a painting. You can make the limbs look as if they are receding by putting them in shadow. Notice when viewed from the front how small the front of the left calf appears as the left leg is lifted off the ground.

Tango

Dance is a challenging subject to paint. I chose the tango because it has a very precise range of repeated movements so I could focus on a typical pose to paint the picture. I watched a group for some time and took photographs, as the dance is fast and furious.

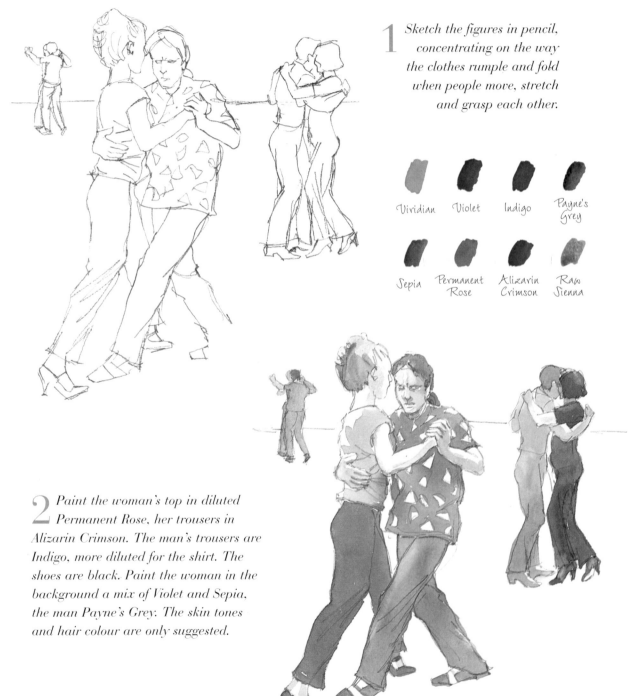

1 Sketch the figures in pencil, concentrating on the way the clothes rumple and fold when people move, stretch and grasp each other.

Viridian Violet Indigo Payne's Grey

Sepia Permanent Rose Alizarin Crimson Raw Sienna

2 Paint the woman's top in diluted Permanent Rose, her trousers in Alizarin Crimson. The man's trousers are Indigo, more diluted for the shirt. The shoes are black. Paint the woman in the background a mix of Violet and Sepia, the man Payne's Grey. The skin tones and hair colour are only suggested.

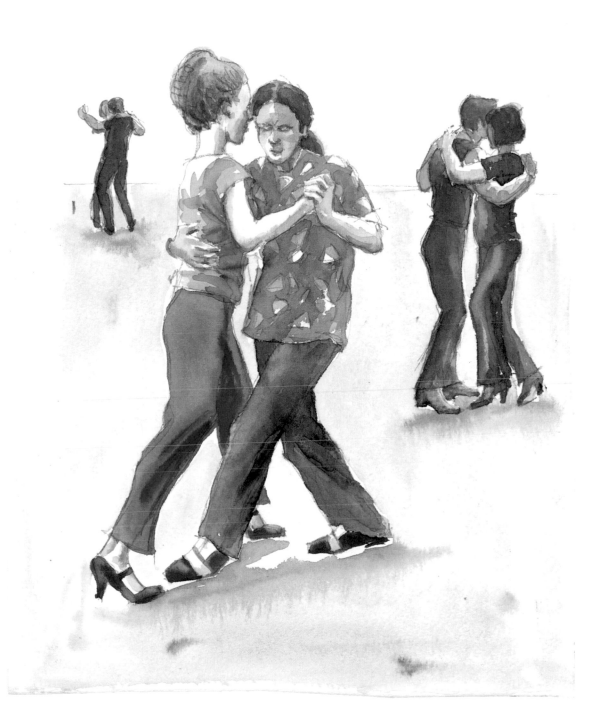

3 *Increase all the shadows, using Violet and Permanent Rose for the woman's top, leaving touches of the white paper, more Alizarin Crimson with a touch of blue for the folds in the trousers. The man's shirt and the folds of his trousers are sharpened up with Viridian and more Indigo. Paint the limbs Raw Sienna, adding form to the man's arm and face with Sepia. Add the shadow areas on the figures in the background using the same colours as before but less diluted. The floor is painted in a dilute wash of Raw Sienna.*

AT A GLANCE...

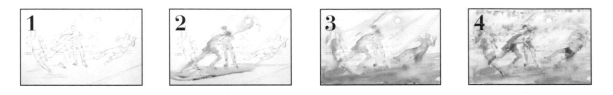

1 2 3 4

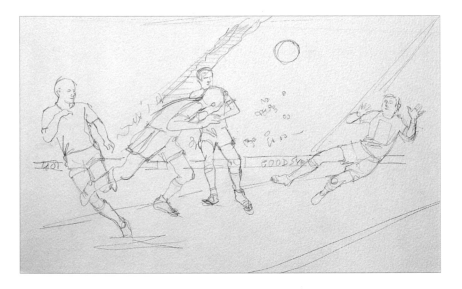

1 Sketch the figures lightly, using an *HB* pencil, keeping it very free. The idea is not to produce figures that look frozen, so the paint will not be kept strictly within the drawn edges of the individual figures.

2 Wet the paper thoroughly, letting the colours Cadmium Red, Hooker's Green, Payne's Grey, Gold Green and Sepia drift into each other, not keeping within the sketched lines. Leave the space clear for the ball shape, either dab it out or wet around it.

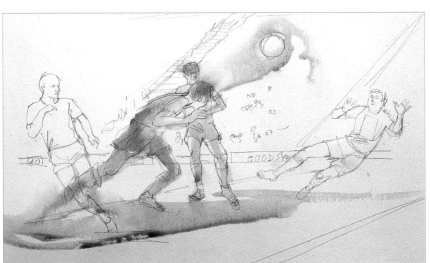

The palette

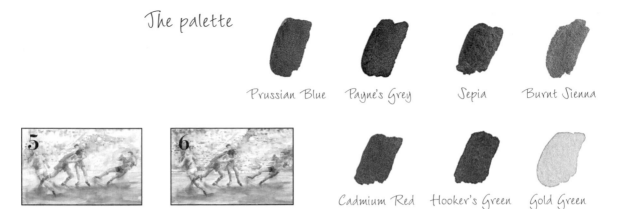

Prussian Blue Payne's Grey Sepia Burnt Sienna

Cadmium Red Hooker's Green Gold Green

3 Continue adding the colours. You will see that if you flood very wet colour into a damp surface you will get 'back runs' which look like blotches but which add interesting texture and prevent the picture from looking static.

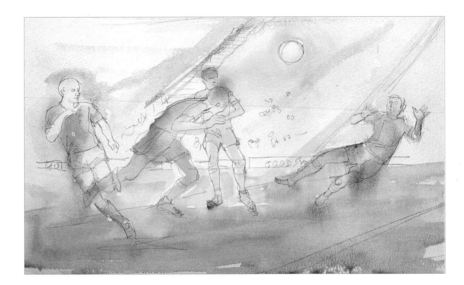

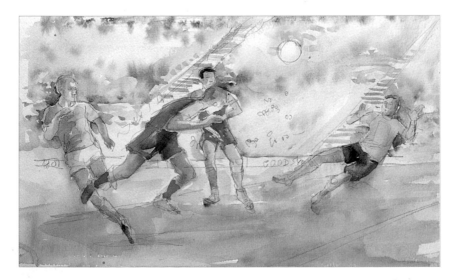

4 Here the picture begins to come together. Add Burnt Sienna on the limbs, wetting the paper first if it has dried out. Add more red to define the figures, this time on a dry surface, to sharpen up the shapes. Then start to define the terraces with greys and browns.

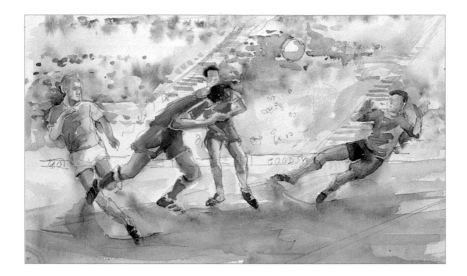

5 To increase the idea of sweeping movement, wet an arc shape between the legs and drop in Prussian Blue mixed with Hooker's Green. Add detail very loosely to the boots, heads and shirts, and add blue shadows to the background crowd.

Detail: *Notice how the crowd is just suggested by applying blobs of paint wet-into-wet to show the faces. The lines of the steps are painted with a dry brush.*

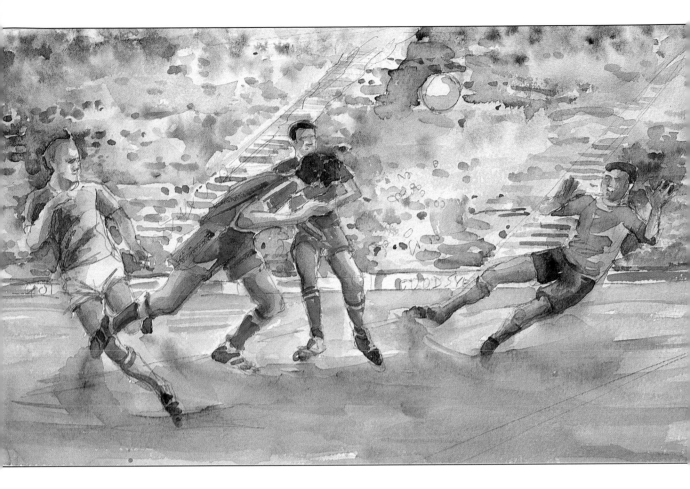

6 *Finished picture: Bockingford 300 gsm (140 lb) Not paper, 22 x 38 cm (8½ x 15 in). Work more into the background with a dry brush, suggesting the crowds with blobs, and using lines for the steps. Add Gold Green to bring the foreground into focus. Add some detail to the crowd in Sepia and Payne's Grey to help reveal the players' heads. The shapes emerge in part but also melt into the picture.*

CHILDREN

Painting children is no more difficult than painting adults. The main difficulty is that they are less likely to be able to sit still for you to paint them, so unless you can work quickly it is best to work from photographs. Children can also look especially self-conscious, so they are best caught unsuspecting. Don't forget to check the scale and proportion of children's heads and bodies (see page 25).

Girl

This is an eight-year-old girl painted in profile. I was very sensitive in my use of colour in her skin tones, and used a very delicate touch.

This girl is captured in animated play, and is obviously enjoying herself, so the expression on her face is vital. Notice how little definition there is in her face, with just a suggestion of features.

Boy in hat

The main difference between the profile of a child and that of an adult is how rounded and full the chin and cheeks of a child are.

1 *Make a pencil sketch of the profile.*

2 *Mix Naples Yellow, Cadmium Red and a tiny touch of Cadmium Orange for the skin tones. Paint the cap Burnt Umber, and the top diluted Black.*

Naples Yellow

Cadmium Orange

Cadmium Red

Burnt Umber

Cobalt Blue

Black

3 *To pull out the prominent features, add a touch of Cadmium Red on the nose, mouth, chin and ears. Shadows under the neck and chin are diluted Cobalt Blue. Intensify the cap and top with the original colours.*

Girl standing

When painting children, the way they stand is enough to distinguish them from adults. This little girl stands shyly and awkwardly, a natural position for her.

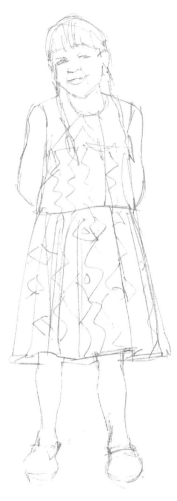

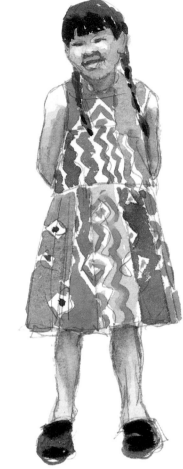

1 *Sketch in the details with an HB pencil.*

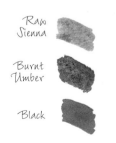

Raw Sienna

Burnt Umber

Black

2 *Paint the skin tone in very diluted Raw Sienna, leaving the paper showing through on the cheeks as highlights. Once dry, add a touch of Black to shape the limbs. The hair and shoes are painted Black, and a light touch of Black is used for the eyes. Burnt Umber gives the shadow on the face.*

3 *Paint the dress very swiftly in bright colours and bold patterns.*

Cadmium Orange

Cadmium Red

Cadmium Yellow

Cobalt Blue

Girl sitting

I photographed this little girl sitting naturally in a cross-legged position as I wanted to capture her wistful expression as she played.

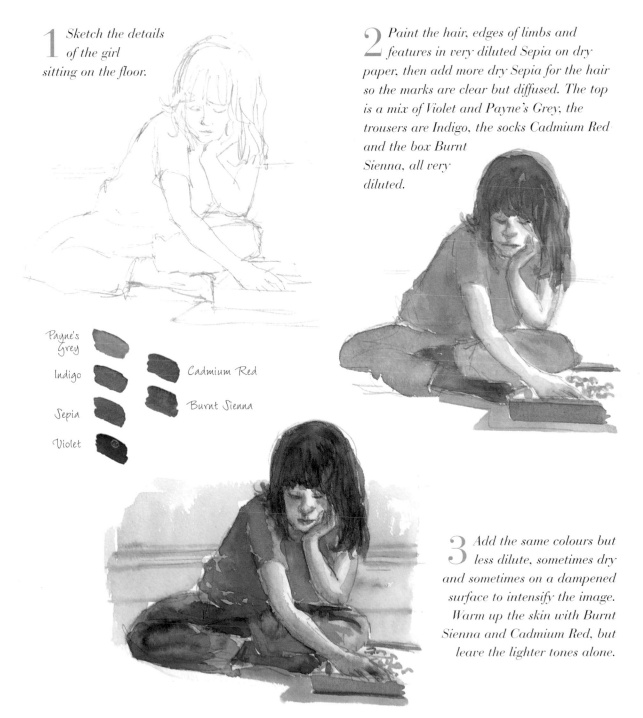

1 *Sketch the details of the girl sitting on the floor.*

2 *Paint the hair, edges of limbs and features in very diluted Sepia on dry paper, then add more dry Sepia for the hair so the marks are clear but diffused. The top is a mix of Violet and Payne's Grey, the trousers are Indigo, the socks Cadmium Red and the box Burnt Sienna, all very diluted.*

Payne's Grey
Indigo
Sepia
Violet
Cadmium Red
Burnt Sienna

3 *Add the same colours but less dilute, sometimes dry and sometimes on a dampened surface to intensify the image. Warm up the skin with Burnt Sienna and Cadmium Red, but leave the lighter tones alone.*

Boys playing rugby

I sketched these boys from a photo. so they look a little frozen and awkward. but moving figures can appear ungraceful if they are caught mid-leap.

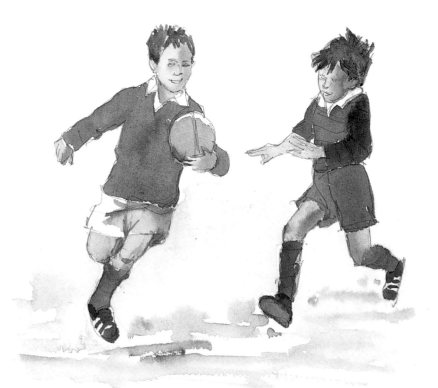

1 *Draw in the detail of the two boys using an HB pencil.*

2 *Paint one shirt and pair of shorts in Prussian Blue, the other shirt and socks in Cadmium Red, the skin in Naples Yellow, the hair in Sepia and Burnt Sienna, and the boots and shadow on the ball and shorts in Payne's Grey. The grass is painted with Gold Green.*

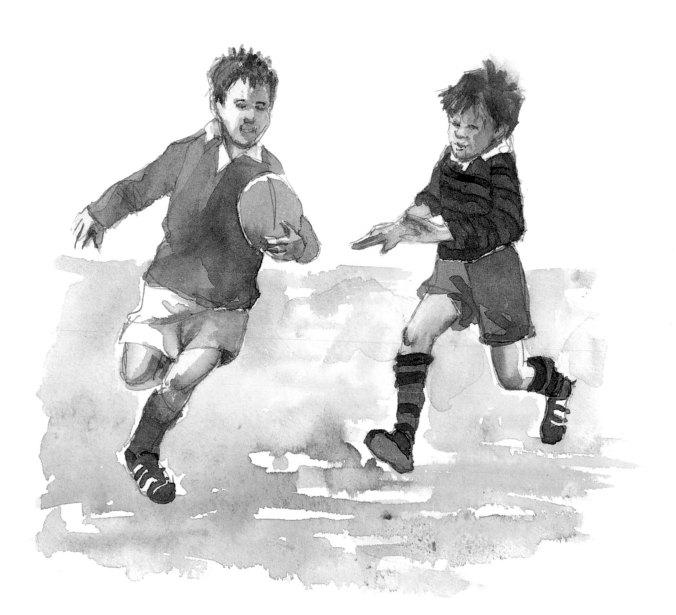

3 *Add shadows on the shirts and shorts with Payne's Grey, add the stripes, and increase the form of the limbs and heads with Burnt Sienna and Cadmium Red. While the grass is still wet, add some Emerald Green.*

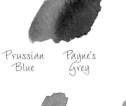

Prussian Blue Payne's Grey Naples Yellow Cadmium Red Burnt Sienna

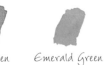

Gold Green Emerald Green Sepia

BACKGROUNDS

People are found in all sorts of settings such as the park, their houses, enjoying themselves eating and drinking. By now you are familiar with how people sit, stand and even dance, so we now turn to the background to all this activity. Here the emphasis shifts to integrating the figures into a setting.

Outdoors

This was painted on Hampstead Heath. I wanted the figures to disappear and become part of the background, and they really do seem to have almost vanished from the final picture. They didn't spot me as I was a long way away from them and I kept looking away in the other direction. The people require no detail at all in this setting to create the right impression.

1 *Firstly sketch the scene. The tree and foreground frame the figures.*

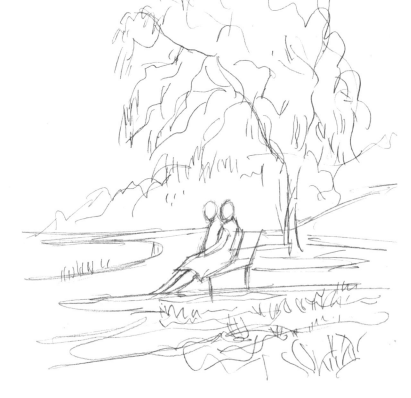

2 *Paint in the figures very roughly and the background broadly in blues, yellows and greens (blues mixed with yellows).*

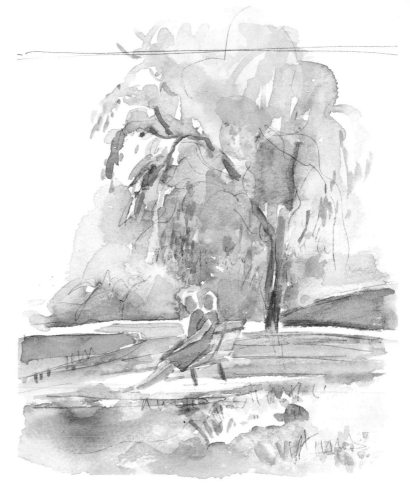

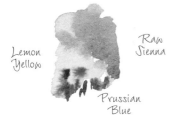

Lemon
Yellow

Raw
Sienna

Prussian
Blue

Alizarin
Crimson

Cadmium
Orange

French
Ultramarine

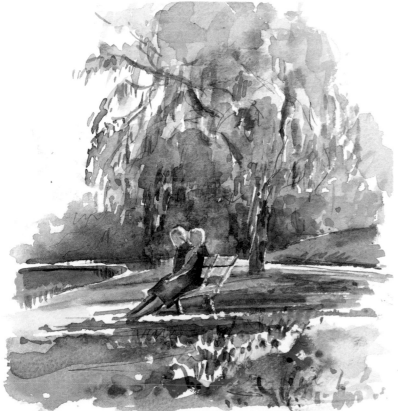

3 *Paint in the trees and foreground with stronger colours, especially the brighter more defined marks to show the grasses.*

Indoors

Working indoors is very convenient, as you have a choice of different locations, control over the lighting, and can stay dry and warm! Try all sorts of unusual settings such as the bathroom, kitchen and utility room as well as the more public areas.

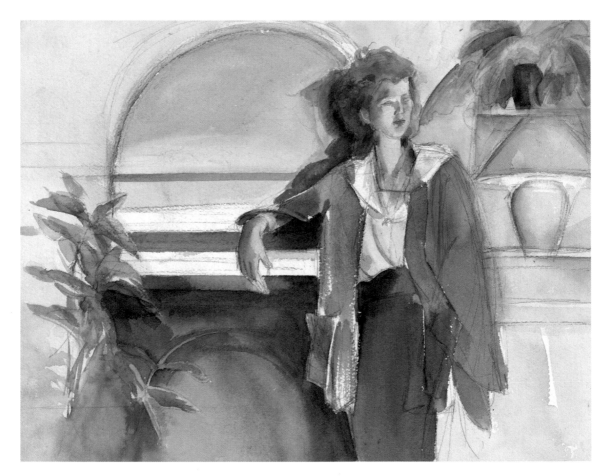

I painted this in my living room. The paper I used was a little rougher than usual so the marks on the top are more broken up as a result. The use of complementary colours is exploited in the orange shawl and blue top. The light hits the figure from one side and slightly below, so the shadows are cast slightly upwards.

In the bedroom

It was important in this picture to create a sense of atmosphere, so the main part of the figure is in semi-darkness. Again, the paper used is very rough and absorbent, so the paint creates unexpected effects and the paper texture shows through.

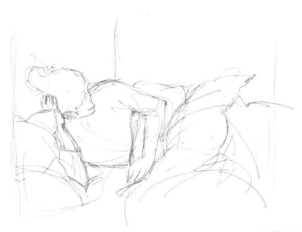

1 Sketch the picture very loosely to create an impression and atmosphere rather than to give an accurate representation.

Payne's Grey Sepia Prussian Blue Alizarin Crimson Cadmium Orange

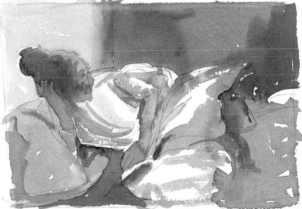

2 Start painting using Sepia and Payne's Grey. This is almost a tonal painting, with very few colours used in varying shades from light to dark. The paper is excellent for dry expressive marks to show the folds of the bedding.

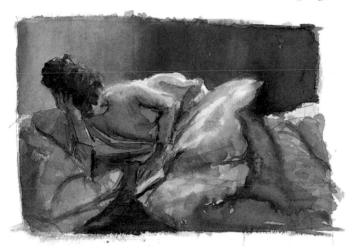

3 Increase the depth of colour using Prussian Blue, Payne's Grey, Sepia, Cadmium Orange and Alizarin Crimson, making the bedding darker, and leaving just a little edge of light.

AT A GLANCE...

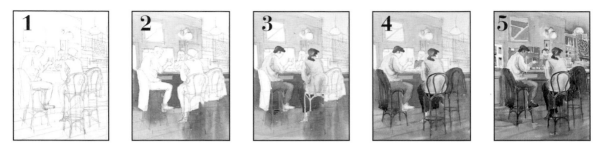

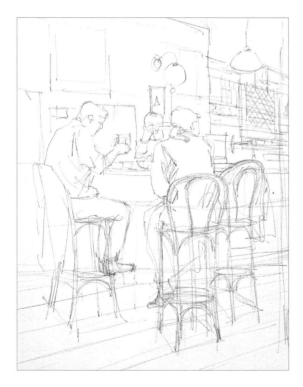

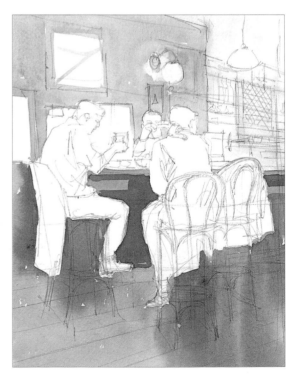

1 *Sketch the details in HB pencil, noting the perspective of the bar and the floor which has lines that converge out of the picture to the right of the figures.*

2 *Using a big brush, paint a Sepia and Cadmium Red mix for the bar, floor and stools. When dry, add more of the mix to make the edge of the bar clearer. Then paint a wash of Naples Yellow for the walls and background, reserving the white paper for the lights.*

The palette

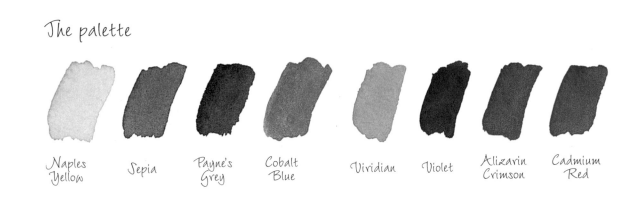

Naples Yellow Sepia Payne's Grey Cobalt Blue Viridian Violet Alizarin Crimson Cadmium Red

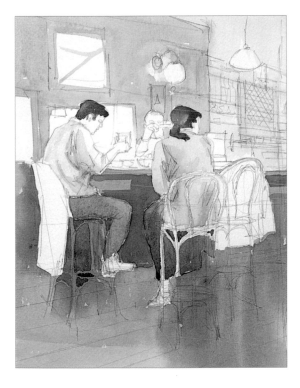

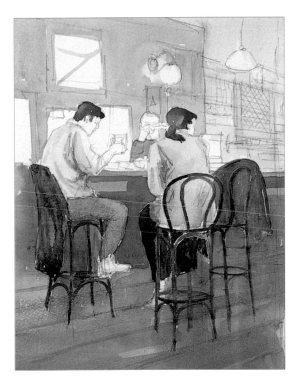

3 *Using a smaller brush, paint the woman's top and skirt in Viridian and Payne's Grey, very diluted, then increase the pigment for the shadows underneath the stool. Paint the man's shirt and trousers in Payne's Grey. Add Sepia for the hair.*

4 *Paint the man's jacket in a mix of Cobalt Blue and Payne's Grey, and a mix of Violet, Alizarin Crimson and Payne's Grey for the woman's jacket. Warm up the foreground and strengthen the direction of the floorboards with lines.*

5 **Finished picture:** *Bockingford 300 gsm (140 lb) Not paper, 28 x 20 cm (11 x 8 in). Add touches of Cadmium Red to the posters in the background and use a smaller brush to draw the details of the shelves and lights in a* Sepia and Payne's Grey mix. Draw the panels on the side of the bar, noticing how they get smaller as the bar recedes. Finish the figures with a suggestion of features and skin tones. Then add shadows on the trousers and shoes.